MEDIEVAL PAGEANT

T&H THAMES AND HUDSON

BRYAN HOLME

MEDIEVAL PAGEANT

Introduction by
TIMOTHY HUSBAND

With 77 colour illustrations

On the title page: Arrival of the procession carrying the helms into the cloister. From the *Livre des Tournois*, Bibliothèque Nationale, Paris

Printed and bound in Hong Kong by Mandarin Offset

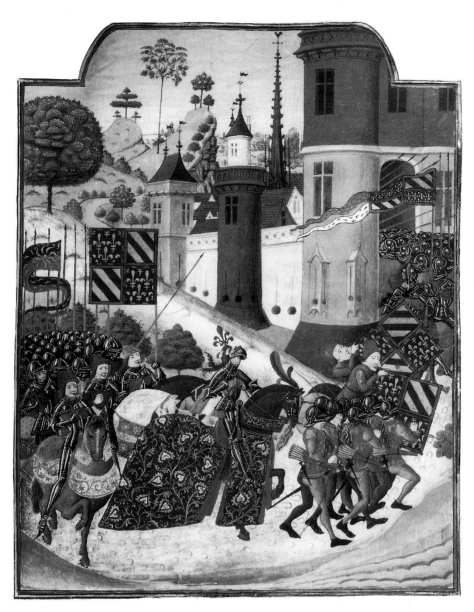

Return of the Duke of Burgundy, from Froissart's *Chronicles*. French, 15th century. (British Library)

PAGEANTRY, in its many exuberant, extravagant forms, played a particularly important role in medieval life. Whether street plays, tournaments, processions, royal entries and funerals, banquets, or dances, medieval pageantry captivated the public imagination. On the simplest level, the lavish displays provided a welcome contrast to the drabness of ordinary life. Pageantry further occasioned the rare opportunity for the lowest to observe the highest first hand. And pageantry was calculated to give the average man the impression he could have some influence over events which affected him. Certain forms of pageantry were, for example, aimed specifically at ameliorating natural conditions in order that crops might flourish. Others occasioned a direct response or expression of sentiment toward a secular ruler, an intercourse which allowed a certain sense of importance to accrue to the most humble. Pageantry furthermore endowed mundane occasions with ritual and sanctity, thus bringing spiritual value to otherwise prosaic events. But for those who staged it, medieval pageantry was not merely a colourful, festive diversion from the otherwise insistent routine of life. These events were deliberately formulated into complex, symbolic ceremonies, frequently laden with polemical or propagandistic intent.

Although we are concerned here only with its secular manifestations, medieval pageantry — and the pageants, which were frequently component elements — was largely derived from or related to Church liturgy and ritual. Events which touched the lives of all — birth, marriage, and death — and those which pertained to a very few — investitures, anointings, coronations — were all given increased importance through the mystery, sanctity, and ritual with which the Church endowed them. Secular life and religious practice became inextricably bound in ceremony and ritual. The many processions of public supplication, such as those for Candlemas, Palm Sunday and Holy Week, the litanies of the feast of St Mark, Rogation days before the Ascension, and Corpus Christi, were popularized canonic rituals staged in public spaces, thus serving far larger audiences than could be accommodated within cathedral walls.

In addition to the celebratory processions, 'extraordinary' processions, which were clearly aimed more at secular than spiritual concerns, were also a liturgically authorized part of the church ritual. These included a variety of processional supplications such as those calculated to bring rain or fair weather, to drive away storms or to otherwise aid agricultural interests. This type of procession evolved into a curious blend of Christian belief, worldly preoccupation, folkloric and pagan traditions.

The symbolism and mystery which lay at the heart of the liturgy reflected a theocentric order in which the Church asserted authority over all matters bearing on man's salvation. By the end of the thirteenth century, however, the broad interpretation exercised by the Papacy had been far more strictly defined by secular authority. All matters temporal were irrevocably — if reluctantly — ceded to hereditary monarchs, thus confining the jurisdiction of the Church solely to the spiritual realm. The princes of state were, perhaps as a result, all the more anxious to sanctify their positions through the ritual of the Church. For this reason, even greater importance was vested in such sacred rites as the anointing of French kings at the cathedral of Reims, their burial rituals in the abbey church of St-Denis, and the papal coronations of the Holy Roman Emperors. The solemn rites that attended these ceremonies, endowing worldly authority with sanctity, developed into the most awesome rituals of kingship.

As these rites were witnessed by a select few, pageantry developed as a means of conveying not only the sanctity of kingship but also the immediate and omnipotent authority vested in it to the masses. Like church processions, secular processions moved to exterior public spaces for all to witness. While these two concepts lay at the heart of all royal pageantry, royal propagandists were skillful in orchestrating these events for specific purposes. Frequently, processions were designed to convince the public of the righteousness of a given cause. The king of France, in an attempt to inspire public resolve with his military struggle against Armagnacs, for example, ordered a procession in 1412. No modest affair, this extended procession lasted from May through July. All the main routes into Paris were followed and every stratum of society participated; some, barefooted, carried relics; others flagellated themselves, while others fervently wept. Witnesses described it as the most moving event in memory. And in spite of considerable hardship, there was never significant popular resistance to the king's military enterprise.

The most impressive of royal processions, however, were entries. Until the fourteenth century, these were fairly simple affairs; the clergy, town officials, guild members, and the bourgeoisie would meet the ruler and conduct him into the town. By the end of the fifteenth century, the panoply of a royal entry evolved into a veritable microcosm of society; the ruler, under a canopy, was surrounded by representatives of the social hierarchy: the nobility, the princes of the church, the ordered confraternities, the merchants, guild members, local officials, and the spectating masses. Royal publicists assiduously exploited these events to communicate dynastic propaganda.

In 1431, the fifteen-year-old Henry VI of England staged his entry into Paris. By the conditions of the Treaty of Troyes, Henry V and his wife, Catherine of France, and their heirs laid rightful claim to both the kingdoms of France and England. To illustrate Henry's dual dynastic ambitions, a pageant was mounted which portrayed — rather optimistically as it turned out — the Duke of Burgundy and the Count of Nevers presenting the crown of France to the young king.

The king, on his return to London, was greeted by a series of pageants staged on various monuments and on specially constructed towers along his route which were intended to publicly justify his genealogical claim to the dual kingship. The first, staged in the middle of London Bridge, not only reiterated the right to both crowns but also addressed the nature of kingship. Personifications of Nature, Grace, and Fortune were shown bestowing all the kingly virtues stemming from the *speculum principis*. In another, fourteen maidens representing the Gifts of the Spirit and the Gifts of Grace were identified with just rule and in yet another pageant, the king was shown exercising these gifts in the presence of two judges and seven sergeants-at-law sitting before him. A wine fountain at Cheapside and boughs of skillfully wrought artificial fruit were intended to be associated with the fruits of this kingship. The fruit tree was followed by a genealogical tree which traced the lineage of Henry VI to St Louis and Edward the Confessor, thus confirming a dual legitimacy. The divine sanctity of the claim was established by associating the royal lineage with the tree of Jesse, the genealogical tree of Christ. The series of pageants closed with an allusion to the divine nature of kingship, showing the anointing and crowning on a throne set in a heavenly paradise surrounded by angels and God himself, who spoke to the king. As a final punctuation mark, a shield on the city gates was blazoned with both royal arms.

By the end of the Middle Ages, entry pageants had developed into a repertoire of remarkably consistent visual and iconographical variants. Allegorical personages — usually personifications of the virtues, biblical figures, saints, and other exempla — became the standard all over Europe. For the entry of Charles VIII at Rouen in 1485, the conceit was further developed; the personifications of the virtues were accompanied by additional attributes, the initials of which spelled Charles: Conseil loyal, Haut vouloir, Amour populaire, Royal pouvoir, Liberalité, Esperance, and Sapience. These devices all essentially served the same function — to remind the prince and his subjects alike of the sanctity of anointed kingship and of the legitimacy of the rightful blood royal heirs to the dynasty.

They likewise illustrated the virtues to which the ideal Christian prince should aspire as they had been laid down in theological writings from St Augustine to

John of Salisbury. The roots of Christian kingship lay in Antiquity and hence, the tenets became more compelling with the coming of the Renaissance. The exercise of these virtues would yield the prince his rewards, usually symbolically expressed in the fruits of the trees and field. These devices further expressed the underlying myth of kingship which set the mystical, sacred rulers apart from all other men.

The allegory of entries was extended to show the nature of the king's government as well. If conceits on the virtues were deemed inadequate to express the king's arbitration of justice, parallels between the earthly and the heavenly rules were drawn. Apocalyptic visions were frequent: the four evangelists surrounded by the twenty-four elders were equated with the four estates – clergy, nobility, burghers, commonality. In the entry of Charles VIII, his father Louis XI was equated with David and thus Charles with his heir, the wise Solomon. In a further chiliastic conceit, Charles was equated with the Emperor Constantine defeating Maxentius thus suggesting that the French royal house was also an ancient imperial house by virtue of its descent from – in addition to Charlemagne – the kings of Troy.

While themes of sanctity, dynasty, mystery, and virtue were standard in entry pageantry, more practical aspects of political interpretation were introduced as well. The spectacle of the late medieval entry reflected not only the increased prominence of monarchs but also that of the urban bourgeoisie who had become natural allies against the aristocracy. City burghers formally presented the keys of the city to the visiting lord, which was understood as a gesture of fealty. An ensuing exchange of gifts was accompanied by a reciprocal guarantee of rights and privileges. It also paid homage to successful international diplomacy sealed by marriage contracts. In November of 1501, Catherine of Aragon made her royal entry into London two days before she was to be wedded to Prince Arthur, heir of Henry VII. This marriage union, which had been a subject of protracted negotiation between the English and Spanish royal houses for well over a decade, brought highly valued continental recognition to Henry's dynasty.

The series of allegorical pageants which were staged at various sites along the route were among the most intricate, thematically coherent, and politically sophisticated ever to be mounted. The honour that would ultimately result from the marriage rather than the union itself was the focus of the display. There were six sections. The first concerned the quest for honour expressed through impersonators of Saints Catherine and Ursula along with astronomical references; the second concerned the necessity for the bride to pursue Honour through the good offices of Policy, Noblesse and Virtue, who greeted and addressed Catherine at an elaborately constructed castle; the third, called the Sphere of the Moon, gave favourable prognostication, through complex interpretation of astronomical readings, for the fruits of the union; the fourth, the Sphere of the Sun, structured as a celestial palace with heraldic and cosmological decoration, dealt with the role of the bridegroom; the fifth, the Temple of God with a heavenly throne, concerned itself with the role of the Prince; and the sixth, the Throne of Honour, the fruits of the marriage achieved by the couple's virtuous pursuit of Honour. Even though the subtleties of this pageant may have been understood by only a few, the elaborate presentations must have impressed the Spanish dignitaries and the common English folk alike.

While the pageantry of the royal entries addressed the sacred authority of kingship, that of royal funerals gradually evolved into a stately symbol of dynastic coherency. In the earlier Middle Ages, the funeral was a ritual of mourning the death of a ruler and of venerating his mortal remains. Ordinarily, the royal body was displayed with the intention of inciting public, emotional response. When circumstances made this impractical, extraordinary steps had to be taken. Louis IX, for example, died in Algeria leading a crusade to the Holy Land. As the extreme heat made the preservation of the body impossible, his flesh was boiled from the bones which were then returned to Paris for veneration. Preoccupation with the corporeal remains was further evidenced by the common practice of evisceration – even dismemberment – and the separate interment of the various parts. While the entrails might be interred in a place of personal association, the embalmed corpse was reserved for a sacred burial place, such as St-Denis in the case of the Capetian kings.

When Charles VI of France died in October of 1422, the mourning of the deceased still remained central to the funeral ritual. Circumstances, however, forced the introduction of a new element which was to effect all future royal funerals. By the conditions of the Treaty of Troyes, signed two years earlier, the incompetent French ruler was placed under the regency of Henry V of England. Had Henry outlived Charles, the English succession to the French throne would probably have been assured. But this was not to happen, for Henry had inconveniently died two months earlier, placing the matter of succession in serious dispute. The immediate issue of who was to be Charles' chief mourner – the Duke of Bedford or Philippe le Bon, Duke of Burgundy – delayed the funeral by weeks. As the king's poor health at the time of his death and the long interval since then had rendered the body an unattractive object for public display, an effigy was ordered in its stead.

The funeral procession – the most elaborate ever staged (p. 36) – was led by twenty-four criers; behind them came two hundred poor. They were followed by two phalanxes; one comprised university dignitaries and the other representatives of mendicant and other religious orders. Next came the university rector, the Patriarch of Constantinople and the chief provost of Paris. Following were the provosts of Paris, the sergeants-at-arms and the stewards and squires of the realm. Then came the coffin of the king borne by sixteen valets or *hanouars*, members of the salt guild who traditionally held the right to bear the king's corpse. Atop the coffin was a fustian and linen effigy of the king dressed in the robes of state. A canopy over the coffin and effigy was borne by eight sheriffs. Following the body of the king was the chief mourner, the Duke of Bedford, diplomatically leading a company of both English and Burgundians. This display of a lifelike effigy dressed in the full apparel of state was an early ritualistic symbol of dynastic continuity.

By the end of the century, the effigy, introduced as an expediency, was fully integrated into the funeral ritual. This lifelike portrayal of the king in full robes of state symbolized the living kingship and the passing of the rule from one monarch to the next. The theme of dynastic continuity became central to the funeral ritual while the mourning of the deceased was increasingly relegated to a ceremonial adjunct.

The funeral procession of Charles VIII, who died at Amboise in April of 1498, reflects the change in emphasis. Significantly, the chronicler of the event treated the procession from Amboise to Paris and the burial at St-Denis as a separate event from the funeral procession in Paris. In the first and more traditional ritual, the body was displayed at Amboise and then, as was the custom, embalmed, encased in lead and placed in a coffin. The procession to Paris was devoted to the mourning of the king's mortal remains and the attendant escorts were dressed in hooded cloaks in the manner of *pleurants* and carried emblems of their offices in the personal service of the king.

In Paris, however, the emphasis shifted to the effigy, which had been made as lifelike as possible, probably constructed from a death mask. The coffin itself was covered with a great cloth of gold. The procession was led by commissioners followed by four thousand poor and then ranks of criers. Then came the Steward Château Dieu followed by the company of household servants. A rank of trumpeters led an empty chariot drawn by six horses flanked by knights and, on one side, a file of the religious orders of Paris, stewards, infants of honour, the Swiss Guard, *hanouars*, mendicants and the Bishop of Paris, and, on the other, the rector and other university dignitaries. Then came the Squire Blandon, pages, a horse bearing the sword of state, more knights, the sergeants of the mace, king-at-arms, the parade horse, the Provost of Paris, the master of the horse, and, finally, the coffin and effigy of the king borne by sixteen gentlemen flanked by the four presidents of the parliament, the banner of the archers, the ensign and the *fanon* of the king all under a canopy carried by sheriffs and provosts. Following were the first chamberlain, the grand master, the princes in deep mourning, the masters of accounts, chamberlains, knights, archers, gentlemen and the archers of Paris.

The members of parliament wore not gowns of mourning, but their red robes of office; the king's personal ensign, *fanon,* and *guidon* were flying in full colour, not furled. These primary attributes of the monarchy, along with the lifelike effigy, symbolized the notion that 'le roi ne meurt jamais'; in later times, the point was made blatantly explicit by actually banqueting the effigy. The cries of 'le roi est mort' as the mortal remains were interred at St-Denis followed immediately by 'vive le roi' in reference to the successor further underscores the sacred continuity of kingship which the funeral procession dramatized.

Of all forms of medieval pageantry, the tournament has most captured the romantic imagination of ensuing ages. The tournament in a ritualized, public fashion perpetuated the values of the chivalric order which centred on the ideal Christian knight − of whom the king was theoretically the archetype − and his ceaseless quest for honour and valour. Although its roots were entirely military, by the later Middle Ages, the tournament had evolved into three types of orchestrated combat: the joust, the mêlée or *tournois,* and foot combat. All three performed at once constituted a *pas d'arme.* Although they were still thought of as a form of military training, these events were replete with allegorical and ceremonial overtones. A distinction was drawn between the more war-like jousts and the more peaceful ones in which the arms of courtesy, particularly the lance, were blunted or padded with coronals.

As the nobility slowly recognized that the feudal system was a thing of the past, a nostalgia for chivalric sport grew. Many forms were modelled on literary

sources, particularly Arthurian legend. A notable example was the Round Table tournament which comprised a series of jousts played on a circular field using blunted weapons which were generally followed by a feast, all at the expense of the sponsoring lord. Perhaps the most famous of all late medieval round tables was that undertaken by Edward III at Windsor – the site of King Arthur's Round Table, according to Froissart – in 1344. An extravagance of international scope, the lords of Burgundy, Hainault, Scotland, Flanders, Brabant, and Bavaria were, in addition to the ranking English nobility, invited.

The greater resources of the Burgundian court financed tournaments of dazzling complexity which were enhanced by the introduction of allegorical themes and pastoralisms lending a more theatrical tone to the events. On the occasion of the marriage of Charles the Bold to Margaret of York, the festivities opened with an elaborate cartel establishing the allegorical theme and culminated in a several-day-long tournament staged in the marketplace of Bruges. A description of *Le Pas d'armes de la Bergière*, staged by René, King of Anjou, at Tarascon in 1449, states that even the viewers' gallery was built like a thatched cottage.

The King of Anjou wrote the most detailed treatise on the tournament (p. 88–96) and presided over numerous elaborate staged fêtes, some of which lasted for forty days and included not only tournaments but such spectacles as a procession to the lists featuring Turks leading lions by silver chains. René's allegorical settings were generally light and satirical but also contained serious references to his often precarious political situation. Like entries, these tournaments were intended to convey the pre-eminent power of the ruler; those who tilted amongst these fantastical and theatrical displays were also expected to take to the battlefield at the order of their liege. In the sixteenth century, tournament displays reached such apotheosized excesses as to present the sponsor as the tenth addition to the Nine Heroes or Worthies. The tournament, in the North, remained the most potent means of perpetuating the long outdated notions of courtly chivalry well into the sixteenth century. Even though it ultimately became a favorite diversion of the wealthy middle class, the tournament, unlike the entry, was principally designed for the nobility and the knighthood.

The outdoor spectacle of the tournament had its indoor, night-time counterpart in the form of banquets followed by pageants and entertainments. Frequently these were conducted in masquerade among elaborate stagings, decorations, and musical settings. Such banquets were often of enormous extravagance, conducted according to strict and complicated protocols; tables were lavishly set, often featuring elaborate centrepieces which established the allegorical theme of the evening's entertainments, while abundant varieties of exotically prepared food were presented in endless succession.

In the case of the Feast of the Pheasant, staged by the Burgundian court at Lille on 17 February 1454, the fare included numerous courses each consisting of over forty different dishes, all of which were lowered from the ceiling by mechanical cranes. These culinary extravagances were frequently employed not only to impress the guest with the economic health of the lord but also to disseminate political propaganda. At the English coronation feast of Henry VI in 1429, three courses were complemented by various custards molded as leopards

and fleur-de-lis, reminding all present of the Lancastrian claim to both the English and French crowns. The message was reinforced by staged tableaux which accompanied each course and which presented, amongst other scenes, St George and St Denis presenting Henry to the Christ child who holds two crowns above the king's head.

Stagings of such divine approbations were often carried to extremes. At the wedding of Prince Arthur to Catherine of Aragon in 1501, the celebrations included a pageant figure portraying God the Father blessing the couple. Occasionally these interludes or pageants dropped all pretence of entertainment in order to convey an unequivocal political message. The Duke of Bedford, as regent for Henry VI, entertained his mercurial ally, Philippe le Bon, Duke of Burgundy, at Paris in 1429. Bedford staged a re-enactment of the murder of the Duke's father, Jean sans Peur, which had occurred some ten years earlier, as a less than subtle reminder that Burgundy's loyalties lay with England, not with the royal house of France. The play may have had its effect, as Burgundy did not attend the coronation of Charles VII at Reims a week later.

The somewhat polemical pageants associated with these banquet evenings were generally followed by more diverting music and dance, often rudimentarily choreographed. The most infamous instance of dance entertainment was the *Bal des Ardents* staged at the Hôtel Saint-Pol by Charles VI in 1392. Several of the guests, including the king, dressed up as wildmen in costumes of dyed flax. Entering the hall in the middle of the festivities, the Duke of Orléans, curious as to the indentity of the disguised dancers, held a torch too close to one of the participants instantly setting the costume alight. As all but the king were chained together, the other costumes soon caught fire; four of the dancers died of their burns and the rest were severely injured (p. 30–31). As a result of this terrifying experience, Charles VI lost his already tenuous hold on emotional stability.

By the end of the Middle Ages, Europe had shifted from a predominantly ecclesiastical and rural socio-economic structure to one that was urban and secular. With the expansion of international trade and mercantilism, commercial centres, such as Bruges and Antwerp, rose to positions of great wealth and power. While these towns often owed titular allegiance to a prince or emperor, they were governed by town councils presided over by rich merchants and the heads of leading patrician families. In exulting their newly established social and economic position, these wealthy patricians tended to emulate the aristocracy. Not only did they become great patrons of the arts but they also affected the dress, manners, and outmoded codes of a much diminished class. Tournaments, which had once been the domain of the princes were now staged by wealthy merchants or guilds in the town squares. Once outmoded chivalric entertainments perpetuated by the aristocracy, tournaments became, particularly in post-Reformation times, popular, civically sponsored substitutes for saints' days festivities and other church celebrations. The Accession Day Tilts, annually commemorating Elizabeth's accession to the throne, cast the queen as the Virgin of the Reformed Religion.

As economic security was the primary concern of these towns, there was a considerable degree of co-operative effort between wealthy merchants, professional guilds, and skilled labour forces. Sound, stable government was in the

interest of all. And quick to follow the example of their noble models, the merchants employed pageantry to convey their political messages.

Towns in the Netherlands excelled in the mounting of street pageants, usually organized by the guilds, which melded ostensibly religious themes with complex political allegory. The pageants of the entry of Charles V into Bruges in 1515, for example, gave clear expression to the city's expectations of the king. The night-time entry took him through all the main streets and squares; along the route were twenty-seven different spectacles staged in specially constructed architectural frameworks as well as a mock naval battle. Eleven of these were constructed by the Brugeoise themselves while the remainder were provided by the resident Aragonese, Florentines, Genoese, Lucchese, and members of the Hanseatic League, all of whom had commercial interests in the city. Illuminated by torches and candles, the spectacle so impressed Charles that he asked to have the entire entry restaged during the daytime (p. 82, 83). One of the Aragonese constructions exploded due to an improvident use of gunpowder, arousing considerable consternation but causing no harm in the end.

The foreign pageants relied mainly on mechanical and structural effects and eschewed any risky implications. The eleven pageants of the Bruges citizens, on the other hand, were conceived as a coherent sequence, presenting an historical interpretation of the growth of the city's commercial glory and, tacitly, its decline which hopefully would be reversed by this young, great prince. In one of the more obvious appeals to restore the town's economic ascendancy, which had been severely battered by Antwerp, Charles was portrayed assisting Merchandise toppling Fortune from her wheel and replacing her with Bruges.

Most of the pageants, however, were far more complex in their allegorical imagery. One, for example, was in the form of a castle with seventeen turrets each with the arms of one of the city's principal trades. Between the two dominant towers was a huge lion holding the Burgundian flint with an inscription imploring Charles to strike fire against the enemies of the city. The central scene was divided into two parts. On one side was the personification of Bruges from whose breast streamed red wine into a gold chalice held by Louis de Maele, under whose rule Bruges had achieved mercantile greatness. This scene alluded to the city's loyalty to her princes. On the other side was a representation of Moses receiving gifts from the children of Israel to adorn the Tabernacle of God. Classical allusions likened the city to a breastplate protecting the emperor's heart while offering all her goods to him. The Bruges citizens, like the children of Israel, were a chosen people and would obey their prince as the Israelites obeyed Moses and, in return, Charles, like Moses, would lead his people out of the wilderness of declining economic fortunes to a new golden age. Through a similar use of historical, biblical, and mythological parallels the Bruges entry pageants reconstructed the history of the city's rise to greatness. The reversals which had occurred during the reign of Charles' grandfather, Maximilian, his father, Philippe the Fair, and his aunt, Margaret of Austria, were, of course, omitted and were replaced in the sequence by the incidental pageants of the Spanish and Italian community. The intended interpretation was obvious and the inherent appeal to Charles could hardly have gone unnoticed by this young prince.

Other forms of pageants, such as the Miracle and Mystery plays, had long

been performed exclusively within church walls; once adopted by the layman, however, they soon evolved into secular mysteries, allegories, homages to the Virgin or saints, and eventually purely secular moralities. Perhaps the best known of these were the *rederijker* plays mounted throughout the Netherlands by the Rhetoricians' Chambers, or popular literary societies, whose memberships drew on all levels of society but largely on craftsmen, artisans, and smaller merchants. Their poetical and dramatic presentations were performed both publicly and privately; by the early sixteenth century, they participated in numerous celebrations including annual religious processions, carnivals, sundry revelries, and even entries of royalty or other dignitaries. The *rederijkers*, no doubt, were instrumental in the pageants staged for the entry of Charles V at Bruges in 1515. Generally, their productions took the form of farces, humorous plays with a moralizing content, satires, and allegorical dramas.

Certain festivals and other forms of pageantry were ostensibly celebrations of feasts of the religious calendar, although these events frequently inspired every type of expression but spiritual. Shrovetide carnivals and other pre-Lenten festivals usually combined processions, competitions, and pageants which tended to devolve into gluttonous and sensual excesses. *Carne* in 'carnival' could be equated with both food and the flesh. Personifications of 'Carnival' were dressed with rabbits and chickens hanging from their constumes. There were many regional versions of Shrovetide festivals; the *Schembartlauf* in Nuremberg was typical of many celebrated in northern mercantile free cities. The right to celebrate came as a grant from the Holy Roman Emperor to the guild of the butchers as a token of appreciation for their loyalty to the patrician council in the mid-fourteenth century. The celebration consisted of a traditional dance based on pagan fertility rites and was publicly performed by members of the butcher's guild. A similar dance, known as the Butchers' Jump, was performed in Munich. As harbingers of spring, the leaping dancers were harvest prognosticators; the higher they jumped, it was thought, the higher the crops would grow.

The *Schembartlauf*, which also derived from pagan traditions, was a civic event sponsored by the Nuremberg council which soon eclipsed the butchers' dance in importance. The event, organized by the most prestigious families of the city, was heralded by a number of fools who shouted, beat the boys who chased them, and generally aroused the spectators. After a battery of dancers came mounted heralds who threw nuts at the children and emptied eggshells filled with rosewater over the ladies. The heralds were followed by men disguised as demons arrayed in shaggy clothing and wearing goat, pig, stork, and other animal masks, throwing fire and ash, and generally terrifying the onlookers. Behind them came the main participants, the *Schembartläufer*, dressed in bright, elaborate, fashionable and uniform outfits, marching to the strains of fife and tabor. The festival culminated in the storming of a man-drawn float or *Hölle* (p. 20) in the form of a ship, tower, castle or grotesque beast. Manned by demons, the *Hölle* was attacked by the *Schembartläufer* wielding siege ladders, spears, and leafy objects concealing fireworks. The *Hölle*, also fitted with fireworks which were ignited during the storming, was inevitably consumed by flames, while the demon inhabitants fled in defeat. The general disarray continued into the streets lasting for days at a time.

In the Netherlands, similar carnivals such as the *kermis* and the *landjuweel*,

which often, but not always, coincided with a religious feast day, also developed in revelries of considerable excess. The *landjuweel*, for example, was opened by a splendid procession led by a dozen or more lavishly decorated allegorical floats, followed by hundreds of *rederijkers* on horseback, and then as many wagons elaborately decorated and filled with costumed revellers. By some accounts these processions were occasionally even more elaborate than those accorded visiting royalty. The competitions, festivities, and carousings which followed often went on for weeks. Such unruly excesses became the targets of both church and civic reformers, though it was only in post-Reformation times that they were finally curbed. Popular reaction against these events was expressed in works of art, such as Pieter Brueghel's *Combat of Carnival and Lent*.

Medieval pageantry had many roots. The sacred liturgy of the Church, pagan practices from the distant past, royal ritual and propaganda, folkloric traditions of remote regions, and the pomp of lavish ducal courts all contributed to its development. By the end of the fifteenth century, however, various forms of pageantry had been moulded into coherent and symbolic expressions which touched all levels of society. The variety and splendour of the illustrations presented in this volume attest to the important role these lavish, sometimes solemn, sometimes excessive but always passionate, celebrations played in the panorama of late medieval life.

Consulted titles and related reading:

Sydney Anglo, *La tryumphante Entree de Charles Prince des Espagnes en Bruges 1515* (Amsterdam/New York: n.d.); *idem.*, 'The London Pageants for the Reception of Katherine of Aragon: November 1501,' *Journal of the Warburg and Courtauld Institutes*, 26 (1963): 53–89; Ruth Cline, 'The Influence of Romances on Tournaments of the Middle Ages,' *Speculum*, XX, no. 2 (April, 1945): 204–211; Robert Delort, *Life in the Middle Ages* (Lausanne/New York: 1973); Joan Evans, ed., *The Flowering of the Middle Ages* (London/New York: 1979); Ralph E. Giesey, *The Royal Funeral Ceremony in Renaissance France* (Geneva: 1960); Johan Huizinga, *The Waning of the Middle Ages* (New York, 1954); J.W. McKenna, 'Henry VI of England and the Dual Monarchy: Aspects of Royal Political Propaganda,' *Journal of the Warburg and Courtauld Institutes*, 28 (1965): 145–162; Roy Strong, *Art and Power: Renaissance Festivals 1450–1650* (Woodbridge, Suffolk: 1984); Frances A. Yates, 'Elizabethan Chivalry: The Romance of the Accession Day Tilts,' *Journal of the Warburg and Courtauld Institutes*, 20 (1957): 4–25.

A thirteenth-century German knight wearing a plumed falcon's head and carrying the same falcon device on his shield, banner and saddlecloth.

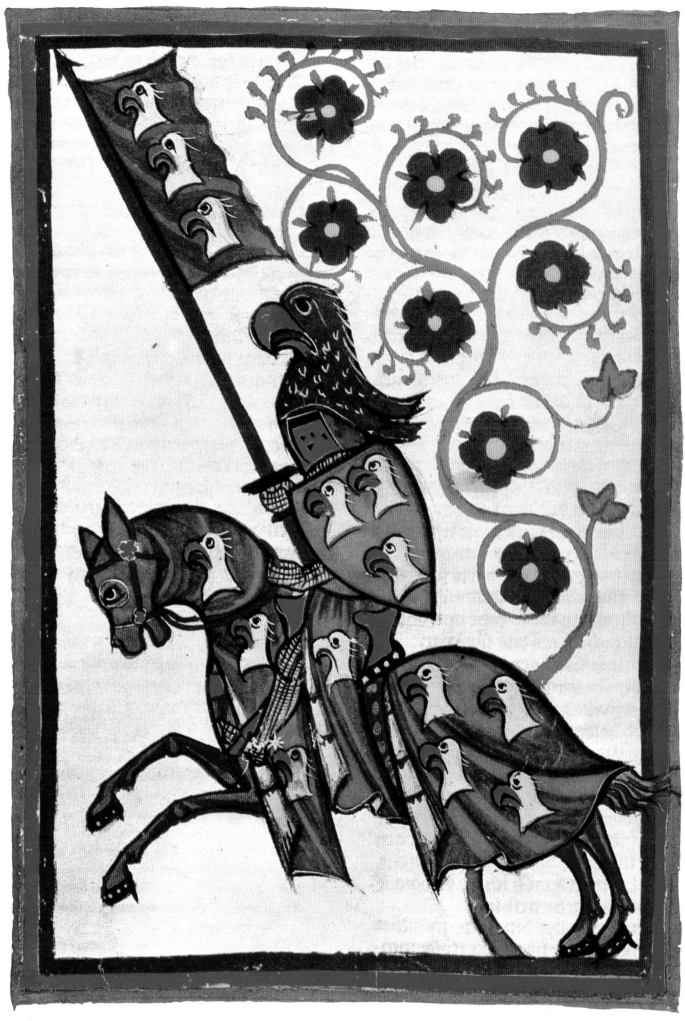

Miniature from Minnesänger
Manuscript, German, c. 1300

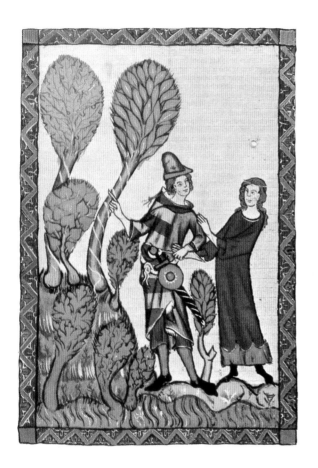

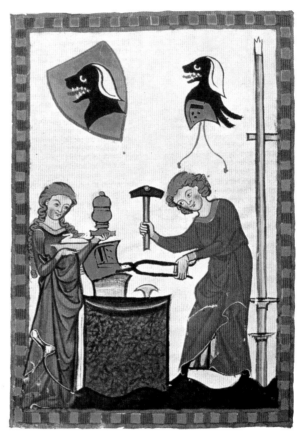

Miniatures from
Minnesänger Manuscript,
German, *c.* 1300

The love-singers

A unique survival from about 1300, the
Minnesänger Manuscript at Heidelberg, preserves
the imagery of medieval courtly love. Each
illustration was made to accompany a song in the
troubadour spirit extolling the virtues of chivalry
and devotion, the popular themes of the day.
Left: a lover invites his mistress for a stroll in the
woods.
Right: a smiling knight repairs his armour with
hammer and tongs as an attentive mistress brings
food and wine.
Opposite: a lady on horseback binds the hands of
her lover with threads of gold, symbol of mutual
love.

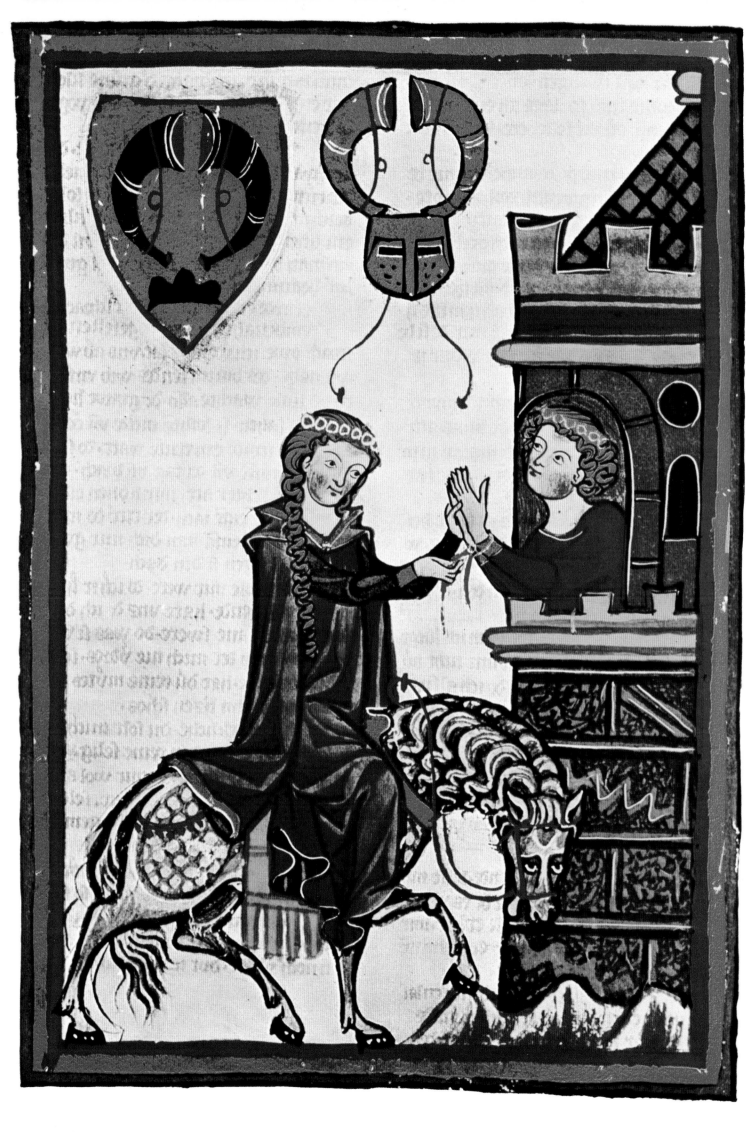

Spiritual battlefields

The climax of the *Schembartlauf*, a festival celebrated in fifteenth-century Nuremberg, was the storming of a float in the form of a ship by the *Schembartläufer* dressed in gay and colourful costumes. The ship was defended by demons, and was in the end destroyed by fire.

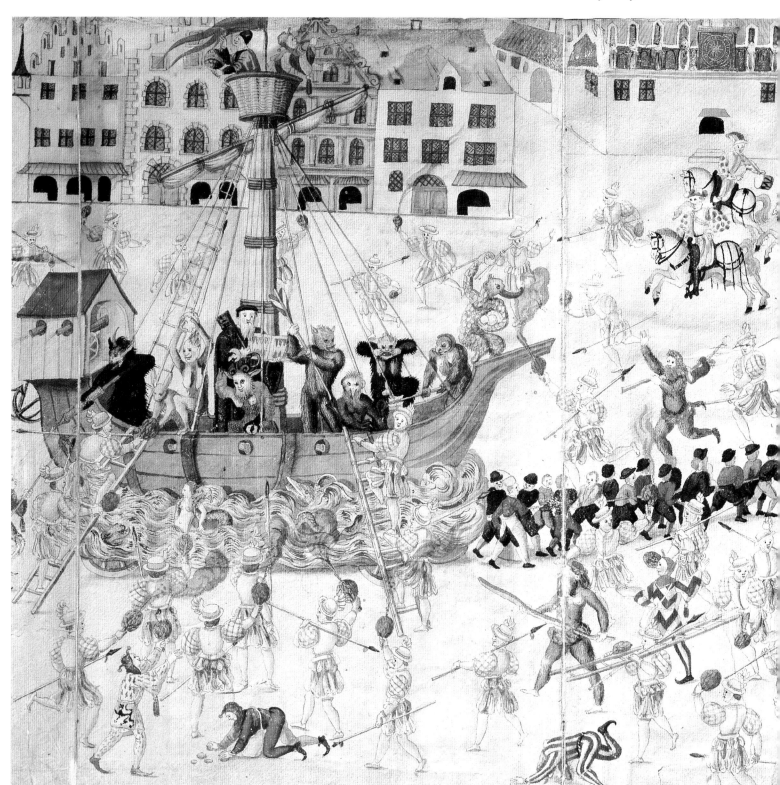

The Schembartlauf, German, 15th century

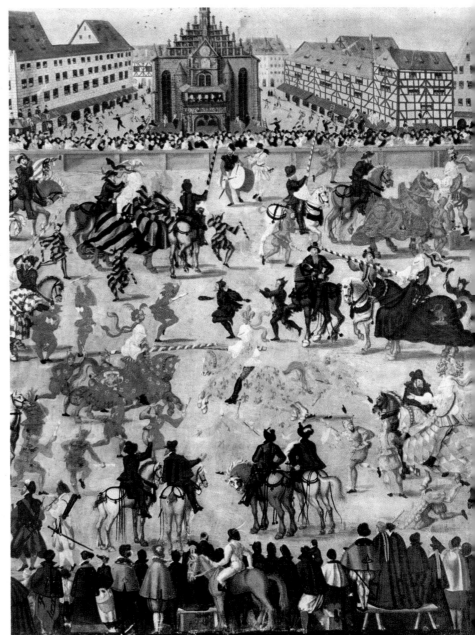

The tournament, which originated as a serious knightly exercise, had by the sixteenth century become a sport. This scene is also set in the main square of Nuremberg. In the specially erected lists jousting knights in bright silk caparison and plumed helms are attended by clowns in parti-coloured costumes acting as squires while tumbling, joking and otherwise playing to the gallery.

Tournament at Nuremberg, 3 March, 1561, German, J. Amman

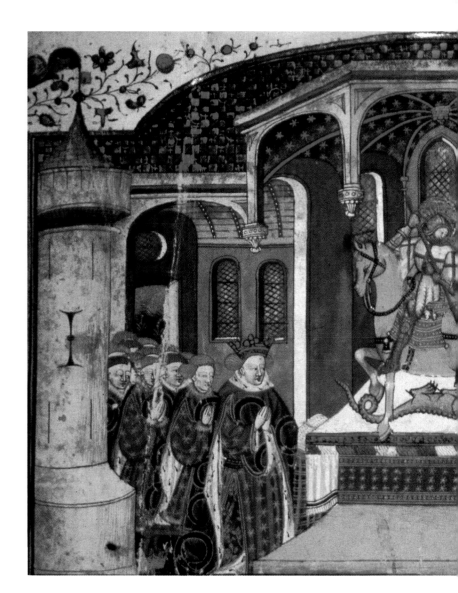

Orders of chivalry

King Arthur was an obscure Celtic leader of the sixth century, but in the late Middle Ages his exploits were enlarged upon and embroidered with such romantic imagery that by the twelfth century – when his knights were linked to the quest for the Holy Grail – he had become the legendary hero of European chivalry. The creed of an Arthurian knight was basically Christian, to defend the poor and oppressed and to be just to friend and foe alike. *Below*: the king welcomes Sir Galahad to the fellowship of the Round Table. *Below right*: King Arthur, in a detail of the Tudor painting on the ancient Round Table at Winchester Castle.

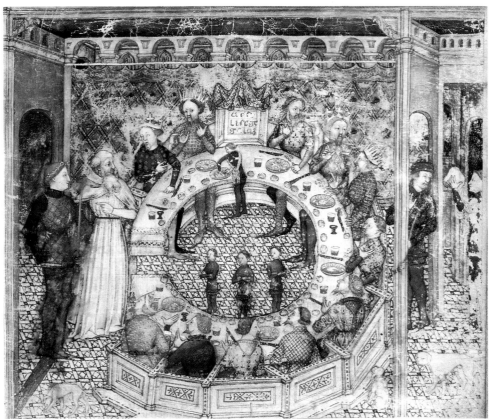

Illumination from a French Arthurian romance, 12th century

Round Table in the Great Hall, Winchester, 14th century, painted 1522

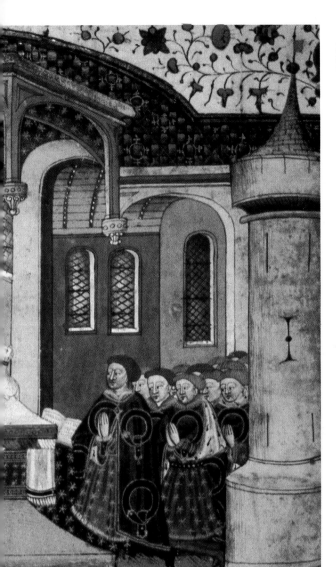

Illumination from the
Statutes of the Order of the
Garter, English, *c.* 1441

Love itself could be seen as a battle, with the castle – symbol of the lady's virtue – to be stormed and captured by the lover's ardour. In this manuscript of about 1300 the women put up a strenuous resistance and the knights, whose arms and armour are portrayed with considerable realism, are not faring as well as they had hoped.

Illumination from the
Peterborough Psalter,
English, *c.* 1300

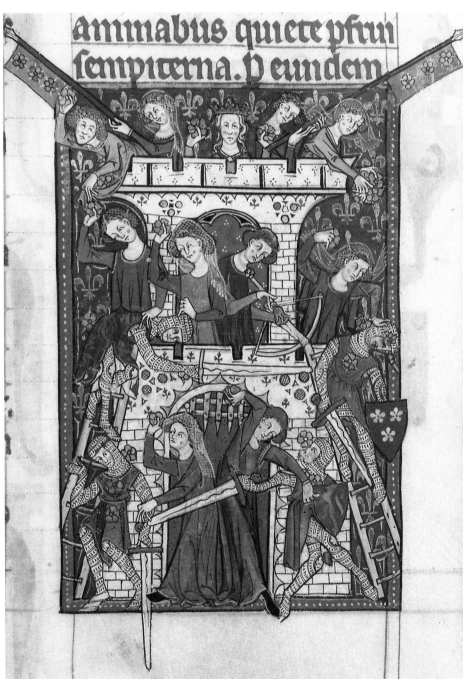

England's Order of the Garter, the most prestigious of the orders of knighthood, was founded by Edward III at Windsor Castle about 1346. The king restricted its membership to himself and twenty-five knights, including his son, the Black Prince. Edward's choice of the French colours, blue and gold, for the garter had direct bearing on his claim to the French throne. The illustration (*above*), made in the reign of Henry VI, is from the book of statutes written in French for Henry's queen, Margaret of Anjou. The king and his knights, in full regalia, kneel before the altar of St George, patron saint of the order, seen slaying the dragon. The motto: 'Evil be to him who evil thinketh.'

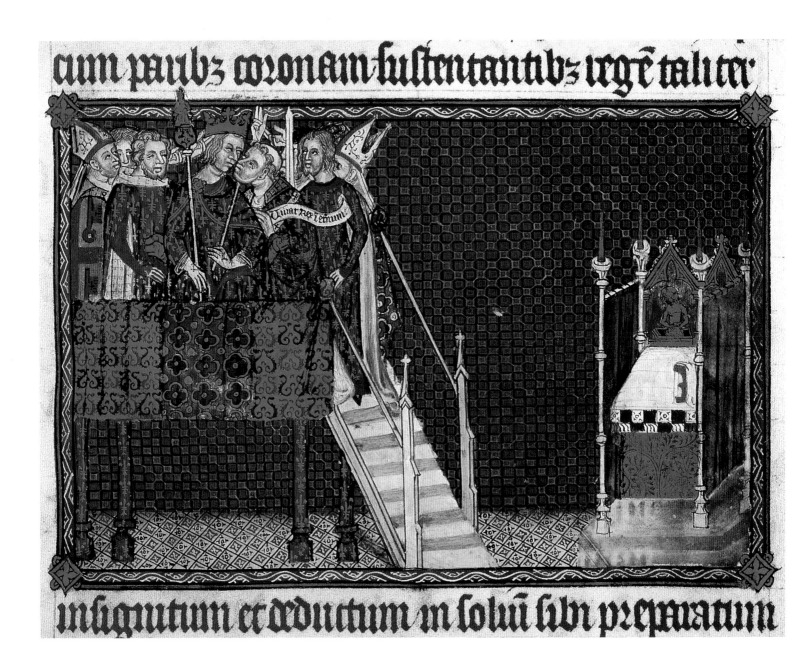

Rituals of kingship

Kissing the king was part of the ceremony of coronation, an expression of loyalty by the peers of his realm. Charles V of France was crowned in 1364. Already he had acted twice as regent for his father, John II: once in 1356 after John had been defeated at Poitiers and held prisoner by Edward III for four years, and again in 1364 when one of the hostages held for John escaped, and John, honour bound, returned to captivity in England where he died the same year. This miniature is from Charles's *Coronation Book*, compiled soon after the event.

A king's banquet is enlivened by a re-enactment of one of chivalry's greatest exploits, the taking of Jerusalem by the Crusaders in 1099. Charles V of France is entertaining the Emperor Charles IV. As they sit at table a boat appears, from which knights disembark and assail the castle on the right. Despite the failure of later Crusades and the fall of the last Christian stronghold in 1291, the ideal of regaining the Holy Land continued to inspire the knighthood of Europe and to be enacted at festivals and coronation ceremonies.

Illumination from the
Coronation Book of Charles V,
French, 14th century

Illumination from the
Chroniques de Charles V,
French, 14th century

24

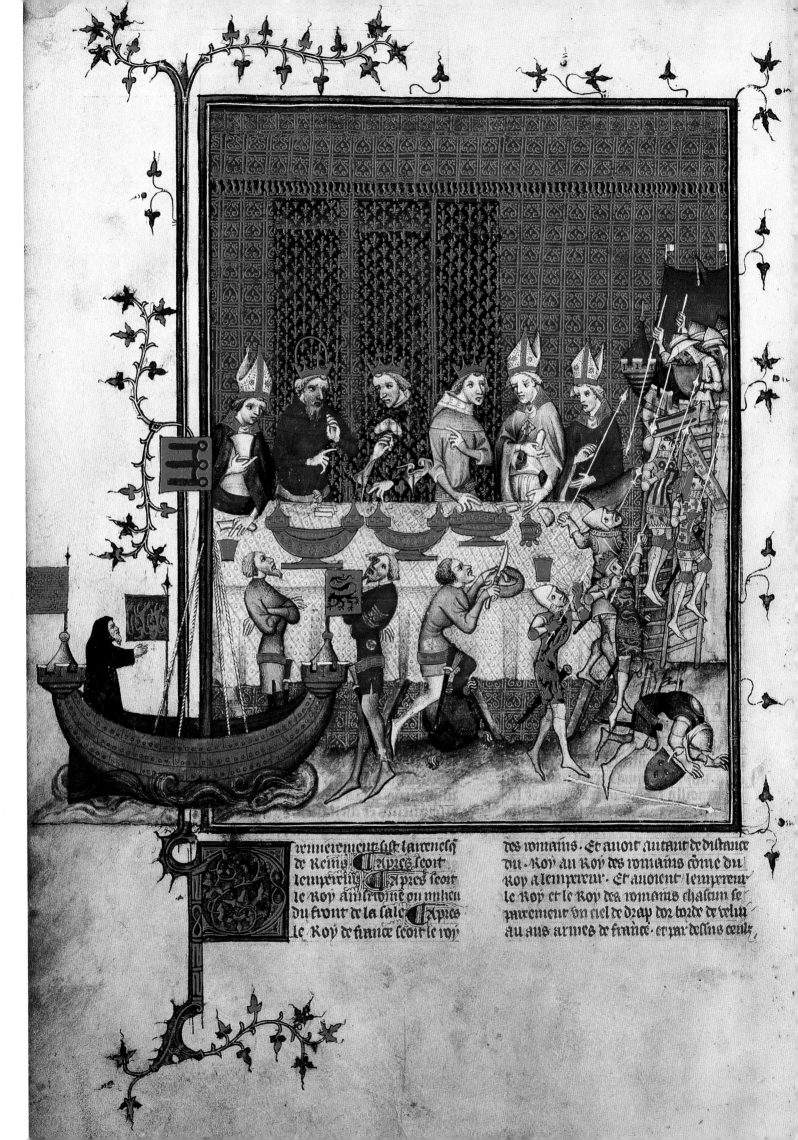

25 of 104 · 9780500014219

remerement sist la rencsch des romams. Et auoit autant de distance
de Reims Apres seont du Roy au Roy des romams come du
lempirisit Apres seont Roy a lempireur. Et auoient lempreu
le Roy ainsi come on miheu le Roy et le Roy des romams chastun se
du front de la sale Apres purement on ciel de drap dor borde de veluu
le Roy de france seoit le roy au aus armes de france. et par dessus ceulz

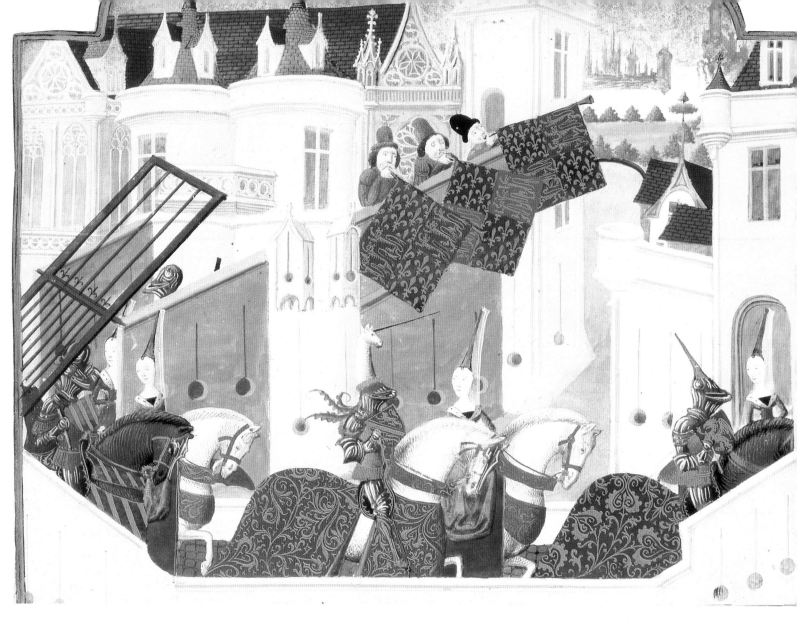

Froissart, chronicler of European chivalry

Jean Froissart was born at Valenciennes in Hainault about 1337 and was attached at various times to the households of the French king John II and of Edward III of England. Edward's wife Philippa had also been born at Valenciennes, and a friendship grew up between her and Froissart which led to his appointment as a clerk of the Queen's Chamber. He began his *Chronicles* about 1357, using documents and hearsay to record the earlier years of Edward's reign, including his invasion of France in 1337 – the beginning of what was to become the Hundred Years' War. But the colourful illustrations added to his manuscript later in the century are more often concerned with the pageantry, elegance and chivalry of the day than with warfare's gory details.

Knights and ladies ride to a tournament in London. On the banners the lions and *fleurs-de-lis* represent England and France. The English then ruled over a large part of northern France, King Edward III, a grandson of Philip IV, claiming to be the rightful heir to the French throne. In the early 1360s, according to one account, London was the most brilliant court in Europe, 'containing at least sixty great personages from France, either as prisoners or as hostages . The Captive King [John II] was surrounded by four dukes of royal blood, half a dozen counts, more than a score of rich barons . . . each brought his own meinie with him, and kept great state in his exile.'

Illumination from Froissart's *Chronicles*, French, 15th century

Isabeau of Bavaria, the eighteen-year-old wife of King Charles VI, enters Paris to be crowned queen of France in 1389. Paris gave her the most splendid reception yet accorded a foreign princess, with tournaments, dances, pageants and masquerades. Festive tapestries and cloth of gold lined the route, and among the attractions was a fountain spouting spiced wine, served in gold goblets by 'sweetly singing maidens'. The illustration in Froissart shows the queen approaching the Porte St-Denis, where dignitaries of church and state (and the king's jester on the wall) await her. In the background are the Sainte-Chapelle and the cathedral of Notre-Dame.

Illumination from Froissart's *Chronicles,* French, 15th century

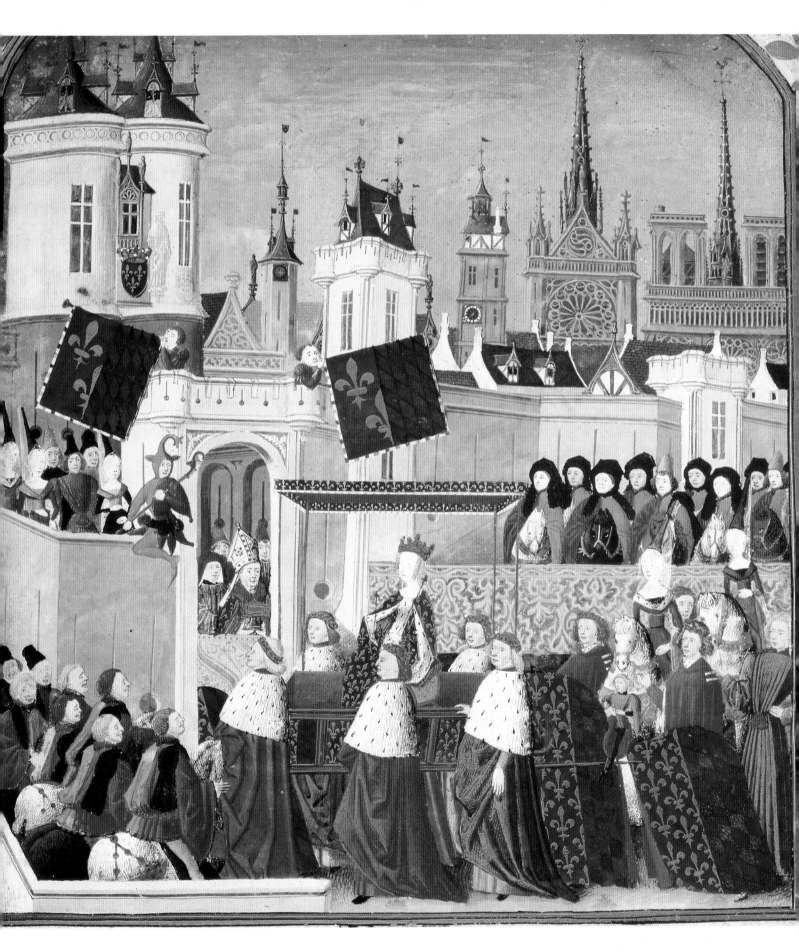

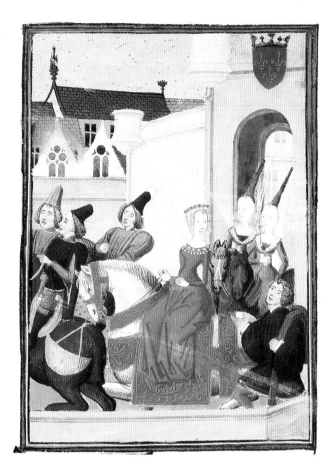

The King of France receives three English envoys who kneel to pay their respects. During the sixteen-year reign of Charles V (1364–80), France recovered most of the territory she had lost to the English in 1356 when the Black Prince (son of Edward III) captured Charles's father, King John II, on the battlefield of Poitiers. But in the reign of his successor, the unfortunate Charles VI, all was lost at the battle of Agincourt. The scene here is typical of the diplomatic side of the Hundred Years' War, followed by Froissart until the end of the century. He died in 1410.

The Duchess of Orléans, the beautiful Valentina Visconti (*above*), leaves Paris after being suspected by a jealous Queen Isabeau of trying to poison the ailing King Charles VI so that her husband, Louis, the king's brother, would succeed him and she become queen. Charles had been struck with madness in 1392 – three years after Isabeau's coronation (p. 27). The politically ambitious Louis thereupon claimed the Duchy of Orléans, but during the ensuing struggle for power he was murdered in 1407 by his cousin John, Duke of Burgundy. This touched off the war between the Armagnacs and Burgundians, once more laying France open to invasion by the English. In 1415 Henry V saw the opportunity, crossed the Channel and won his overwhelming victory at Agincourt on 25 October, St Crispin's Day.

Illumination from Froissart's *Chronicles*, French, 15th century

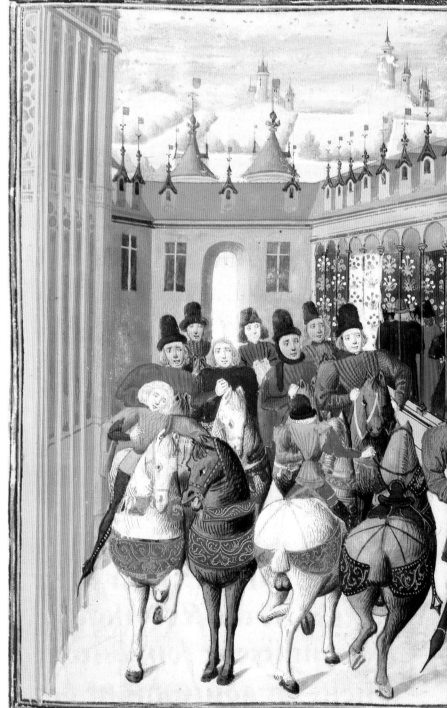

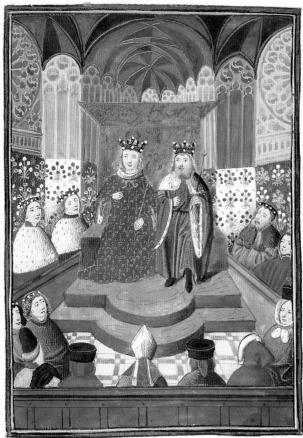

The Emperor Wenceslas and King Charles VI
in council at Rheims in 1397. The two had met to
try and settle the Papal Schism between Rome
and Avignon by persuading the anti-pope
Benedict XIII to resign. 'But,' said Froissart, 'the
Emperor was a notorious drunkard, and incapable
of serious business after a fairly early hour in the
morning; the King on the contrary, was least
crazy after he had eaten and drunk.' Thus, beyond
having their picture painted, little was
accomplished.

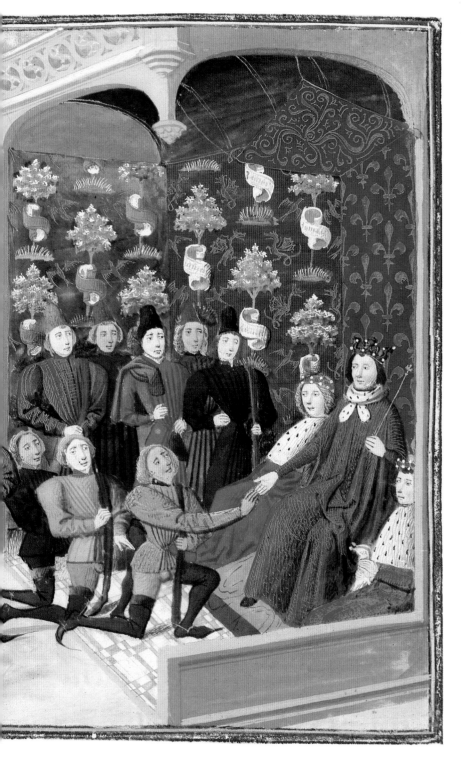

(Overleaf)

The dance of the Wild Men, or savages of the
woods, was a masquerade devised by 'the
cruellest and most insolent of men,' Huget de
Guisay, and performed with disastrous results at
the court of Charles VI of France. The king
himself took part, gesticulating and howling
madly like the other 'savages', until his brother
Louis of Orléans, reportedly just in from a
drinking party, entered with others carrying
forbidden torches. Louis, filled with a mischievous
curiosity, was determined to identify the masked
'savages', who were fastened together and wore
hairy hemp costumes tightly waxed to their
bodies. Then, either by accident or for the fun of
it – there are two versions of the story – Louis let
a spark drop on one of the dancers' highly
inflammable costumes. Flames arose, and amidst
shrieks of horror and of agony quickly spread to
the others. Four died of burns. The king himself
was only saved by the fifteen-year-old Duchess of
Berry who, responding to a dancer's scream 'Save
the king!', suddenly recognized Charles and,
flinging her train over him, extinguished the
flames.

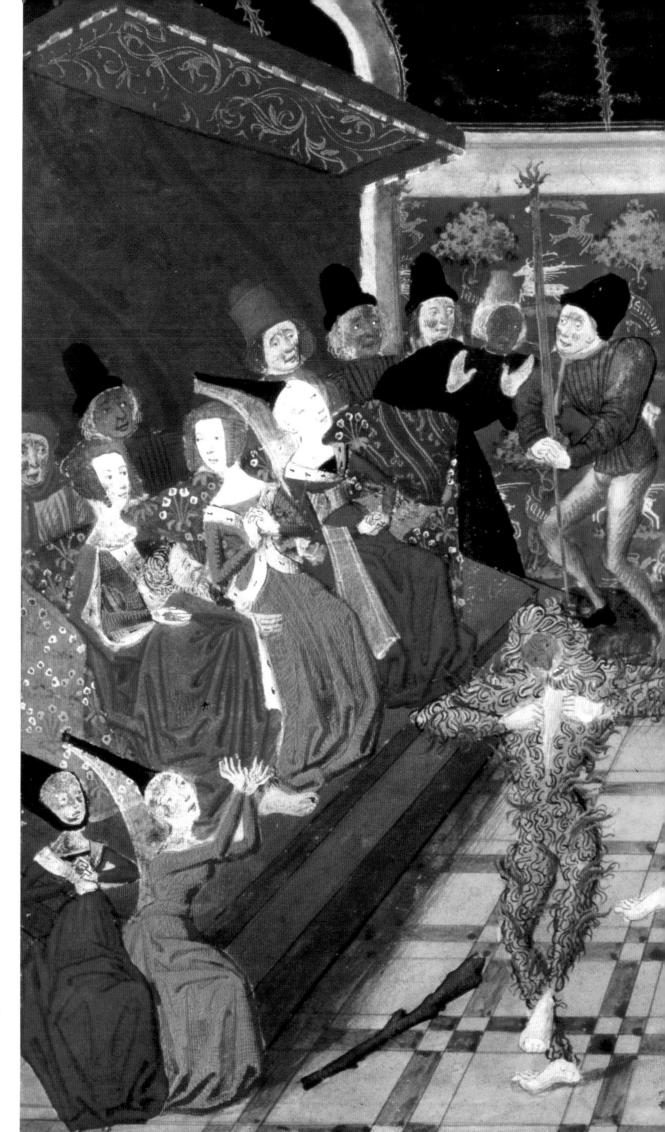

Illumination from Froissart's *Chronicles*, French, 15th century

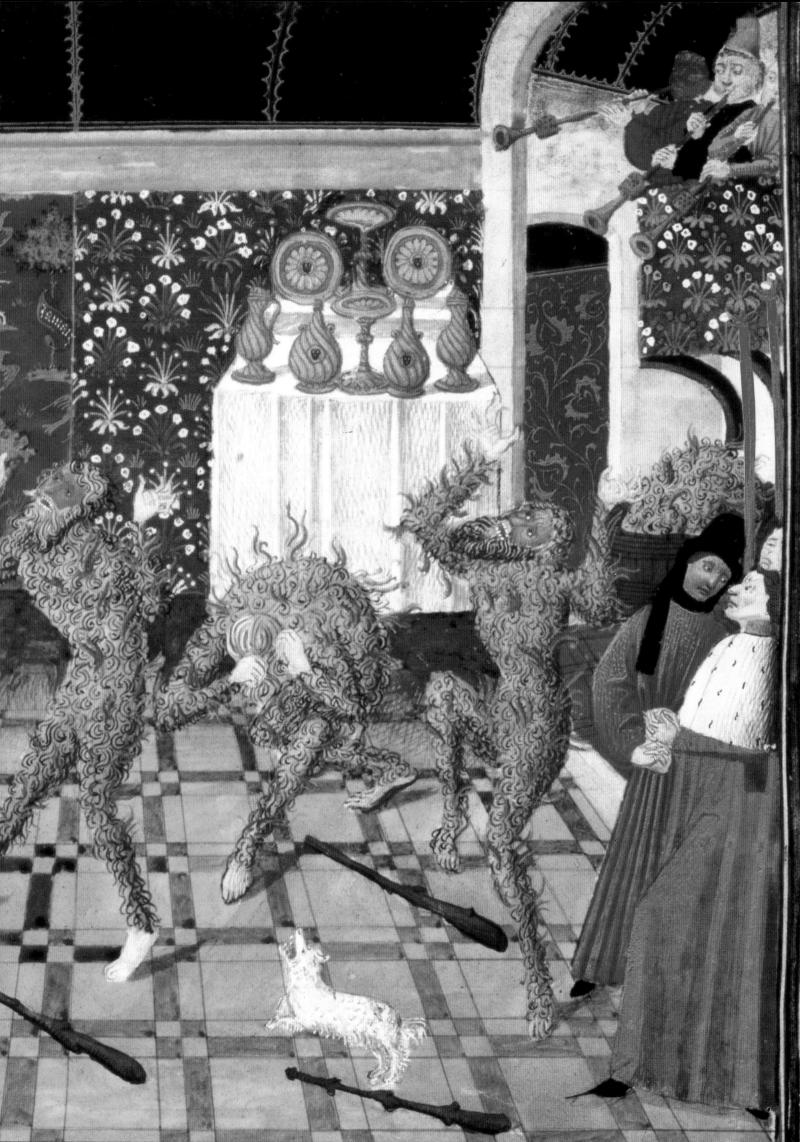

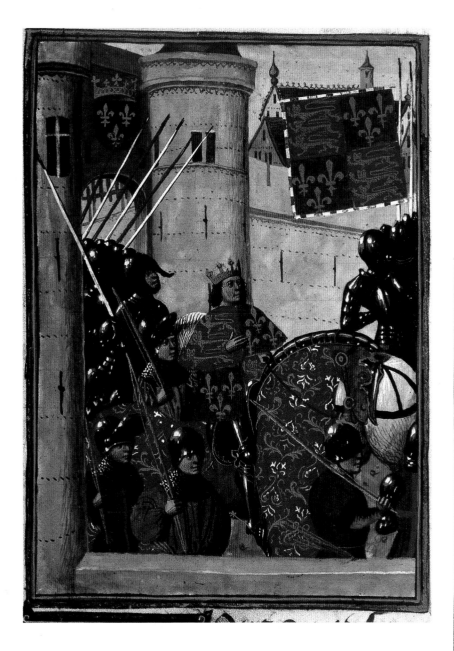

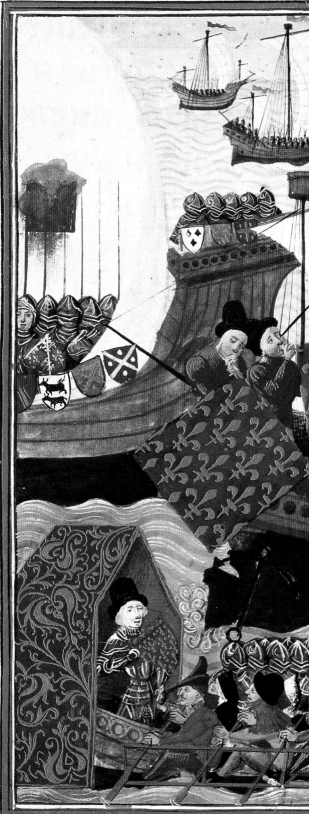

Expedition to the Barbary Coast. The Genoese were endlessly engaged in sea skirmishes with Saracen corsairs who carried any spoils they could lay hands on back to Tunisia. On one occasion a large force, after making a devastating surprise attack on the Genoese homeland, also laid waste their island possessions. The outraged Genoese appealed to the French and English – then observing a truce – for volunteers to help mount a punitive expedition against 'the treacherous infidels'. Froissart, relying on accounts from those who actually took part, records that in the

Illumination from Froissart's *Chronicles*, French, 15th century

King Richard II setting out on an expedition to Ireland where its rulers will do him homage and receive amnesty. The following year, 1396, the king sailed to Calais, and in regal dress, 'stiff with gold and gems,' was married to his second wife, Isabella, the nine-year-old child of Charles VI of France. Part of the marriage agreement was to extend the truce between their countries to twenty-eight years. But by 1399, political discords at home had paved the way for Richard's cousin, the exiled Henry of Bolingbroke, to return to England while Richard was away. Supported by friends in Parliament, Bolingbroke forced Richard to abdicate in 1399 and ascended the throne as King Henry IV. Richard – first held prisoner in the Tower of London, then in Pontefract Castle – died the next year of neglect, if nothing worse.

Illumination from Froissart's *Chronicles*, French, 15th century

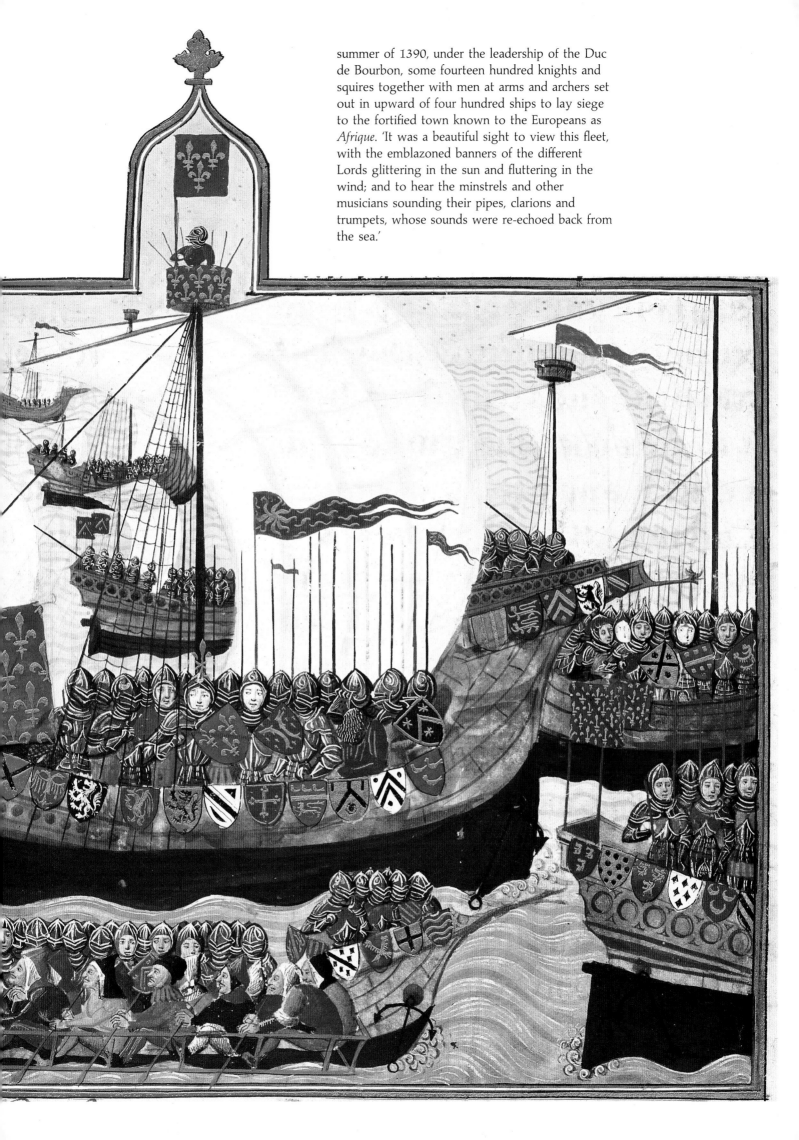

summer of 1390, under the leadership of the Duc de Bourbon, some fourteen hundred knights and squires together with men at arms and archers set out in upward of four hundred ships to lay siege to the fortified town known to the Europeans as *Afrique*. 'It was a beautiful sight to view this fleet, with the emblazoned banners of the different Lords glittering in the sun and fluttering in the wind; and to hear the minstrels and other musicians sounding their pipes, clarions and trumpets, whose sounds were re-echoed back from the sea.'

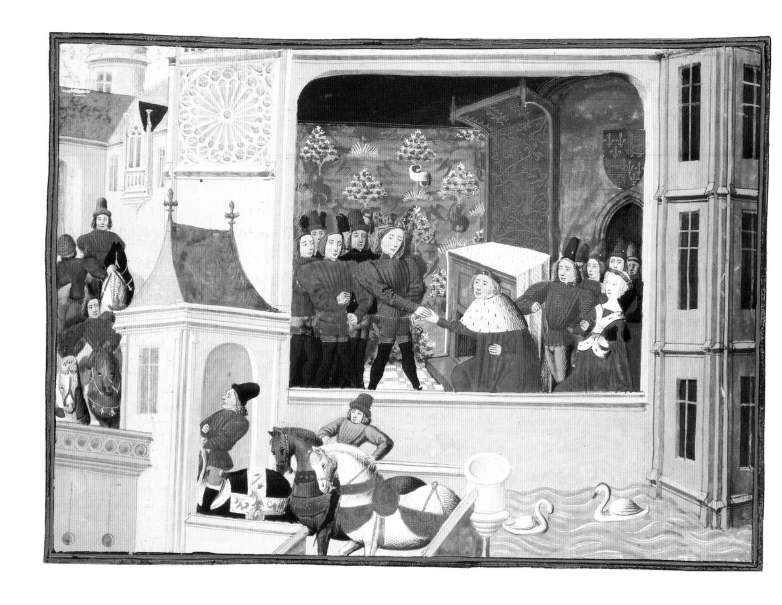

The meeting in Pleshey Castle between Richard
II and the Earl of Gloucester, seventh son of
Edward III. In the struggle for power that
followed Edward's death, Gloucester had been
backed by other Lords Appellant in opposing his
young nephew, Richard, who as the son of
Edward the Black Prince had assumed the throne
in 1377 at the age of ten. In 1389 they managed
to reach agreement, here in Essex. To the
miniaturist's artistic eye, the historic meeting of
nephew and uncle appears to have been of less
importance than the decorative castle, moat,
swans and the colourful pageantry indoors. Eight
years later Richard, backed by Parliament, found
the Appellants guilty of treason and ordered
Gloucester and his accomplices to be put to death.

The Tower of London in the fifteenth century
(*opposite*). Beyond the battlements, the River
Thames flows beneath London Bridge. Seated in
the White Tower is Charles d'Orléans, son of the
first duke, Louis, whom the Burgundians murdered
in 1407. The English captured young Charles at
Agincourt in 1415 and held him prisoner for
twenty-five years. Different scenes show him
writing one of his lyric poems (illustrated and
published with this picture some forty years later),
languishing at his prison window, welcoming the
emissary bearing the huge ransom Henry V had
demanded for his release (left centre) and finally
riding off to freedom. The Hundred Years' War
had barely ended before England, in 1455, was
split by the Wars of the Roses, the struggle for
the throne between the House of Lancaster,
represented by the red rose, and the House of
York, represented by the white. In 1461 the
Yorkists consolidated their victories by crowning
Edward IV king, and later murdering the
imprisoned Lancastrian Henry VI while he was at
prayer here in the Tower.

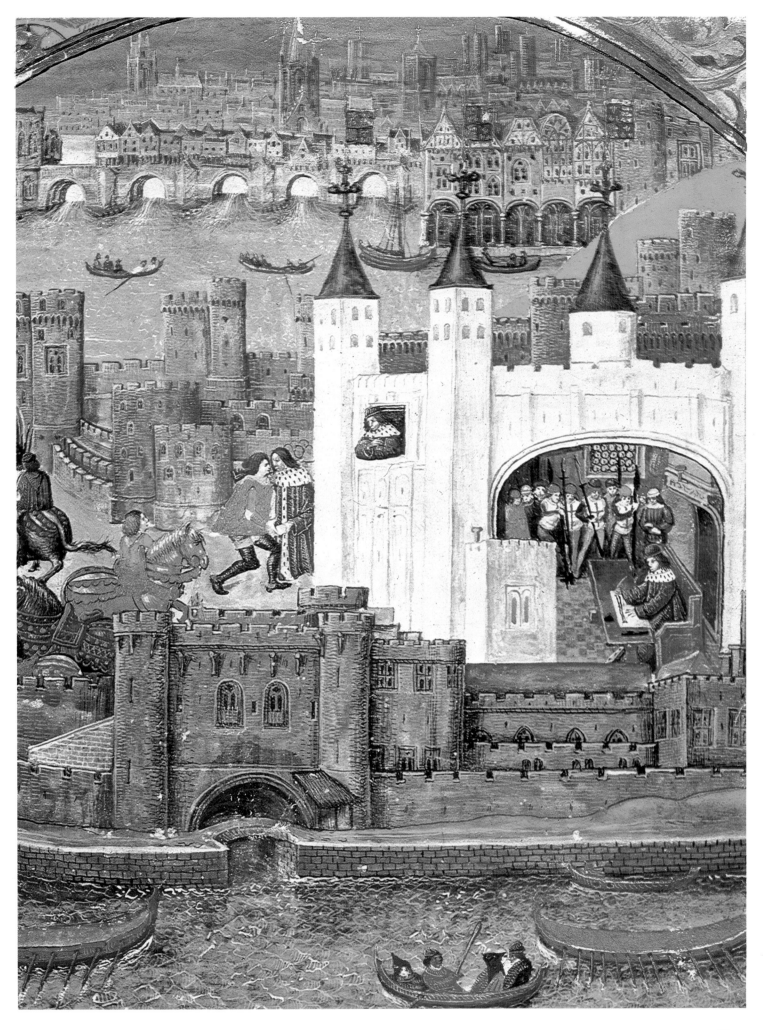

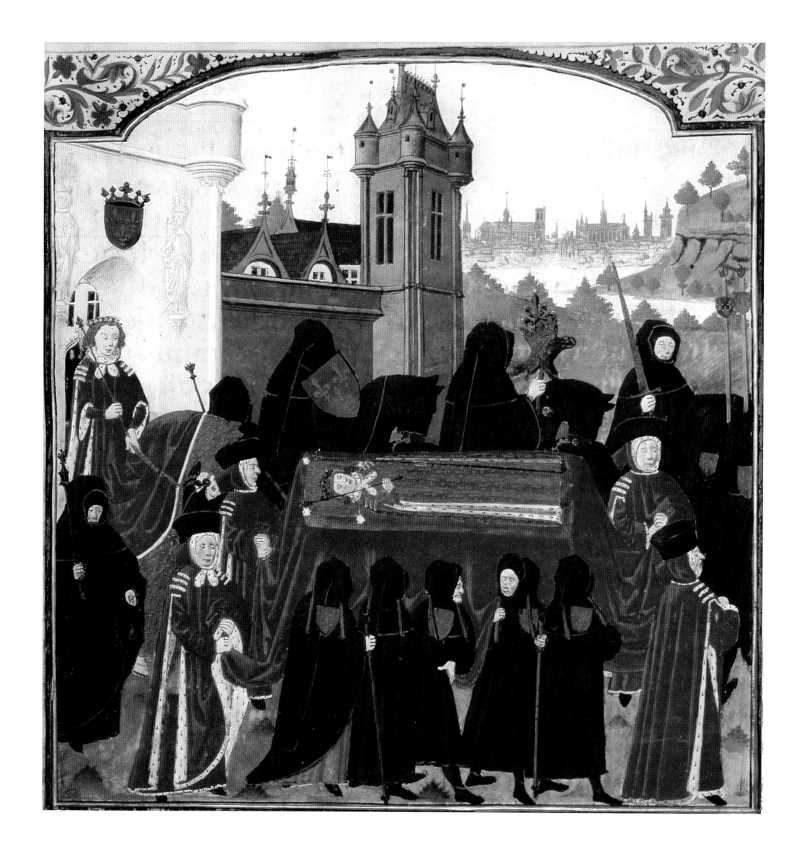

Pageantry of death, pageantry of the law

Illumination from the
Chroniques de Charles VI,
French, 15th century

Trial of the Duc d'Alençon, by
Jean Fouquet, French, late
15th century

Charles VI of France died in 1422 and was buried with his ancestors at St-Denis. This miniature shows the funeral procession leaving Paris. On the bier lies a richly dressed effigy of the dead man. The mourners wear black but the chief mourner, the Duke of Bedford, and members of the Parlement of Paris wear red because 'the king never dies'.

King Charles VII presides at the trial of the Duc d'Alençon, accused of conspiring with the English. Joan of Arc's victories at Orléans and Patay had enabled Charles to be crowned in 1429 at Rheims, seven years after his father's death. But another twenty-four years went by before the English were finally expelled. In the meantime he was not without troubles from his own countrymen.

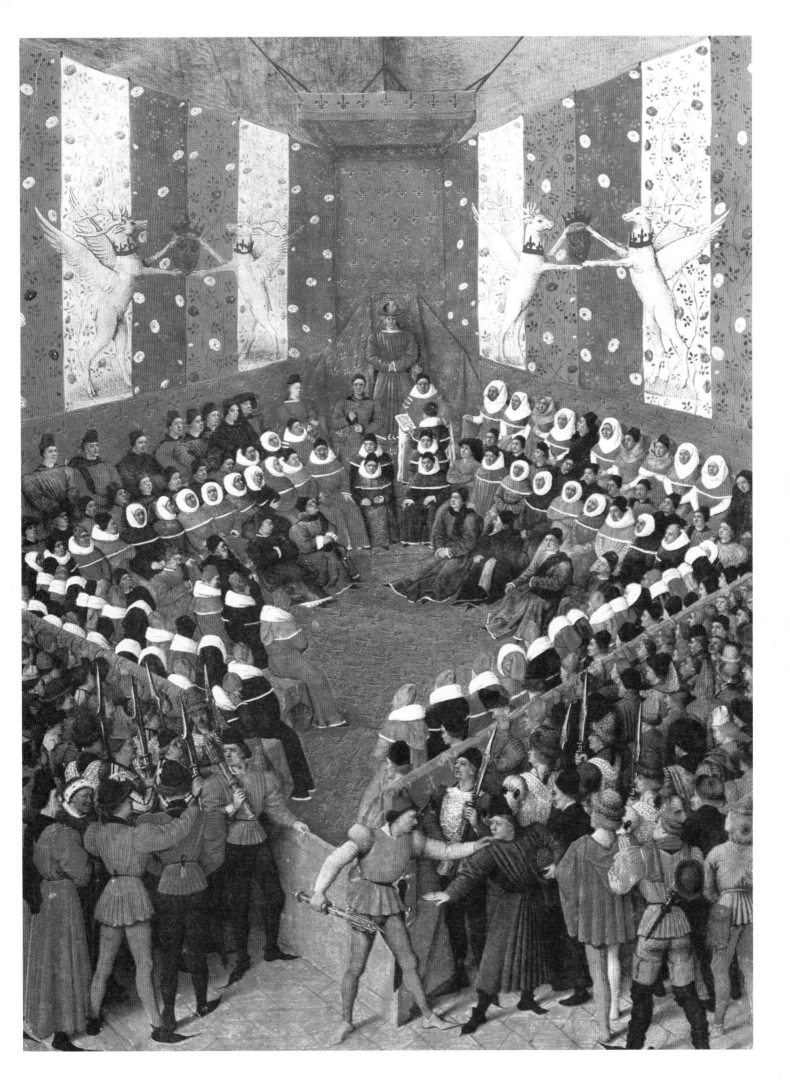

Italian pride: the glory of the Renaissance

Festival in Siena honouring the city's patron saint, the Virgin Mary, on the Day of the Assumption. Lines of dignitaries in magnificent attire followed by groups of clergymen, soldiers, flag-bearers, equestrians, musicians, acrobats, dancers – and floats shaped as dragons and other fanciful creatures – wind their serpent-like way through the Piazza del Campo. With commerce at a standstill, the entire city abandons itself to a day of dazzling pageantry, feasting and fun.

Procession of the Contrade, by Vincenzo Rustici, Italian, 16th century

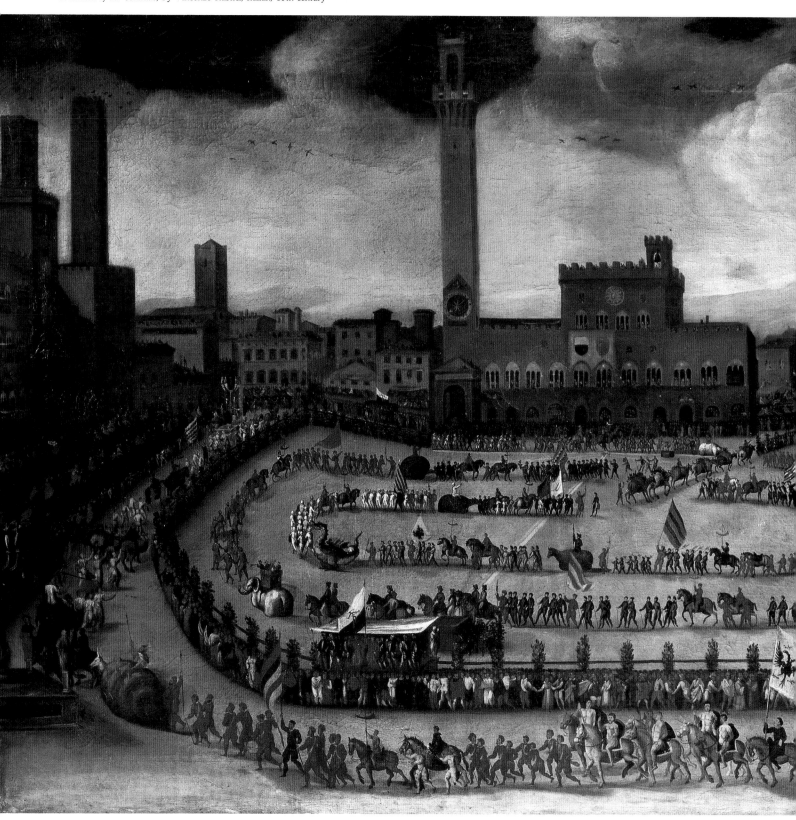

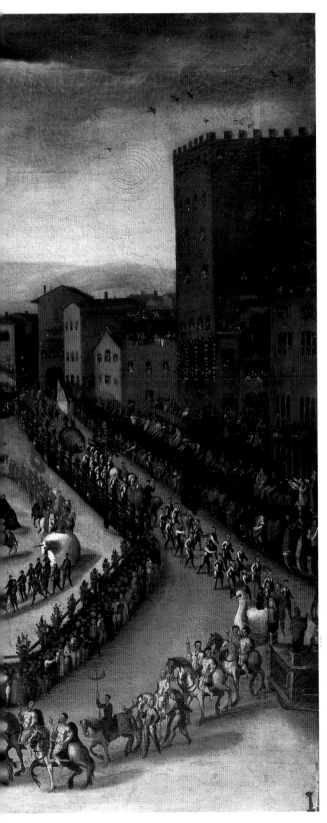

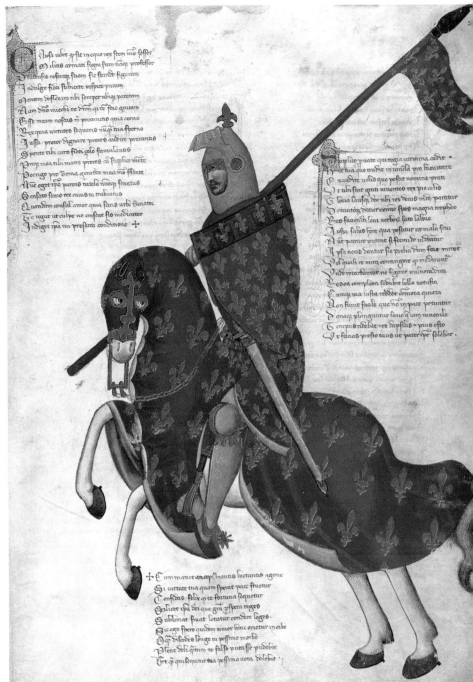

Knight of Prato. The dramatic figure on horseback is accompanied by a text which reads in part: 'I am the symbol of an armed knight of Prato . . . look upon the face of your subject people.' This is the first page of a long address elaborately illustrated with allegorical figures which the citizens of Prato in Tuscany had especially made to present to their protector Robert of Anjou, King of Naples.

Miniature from an *Address* by the town of Prato to Robert of Anjou, Italian, *c.* 1335–40

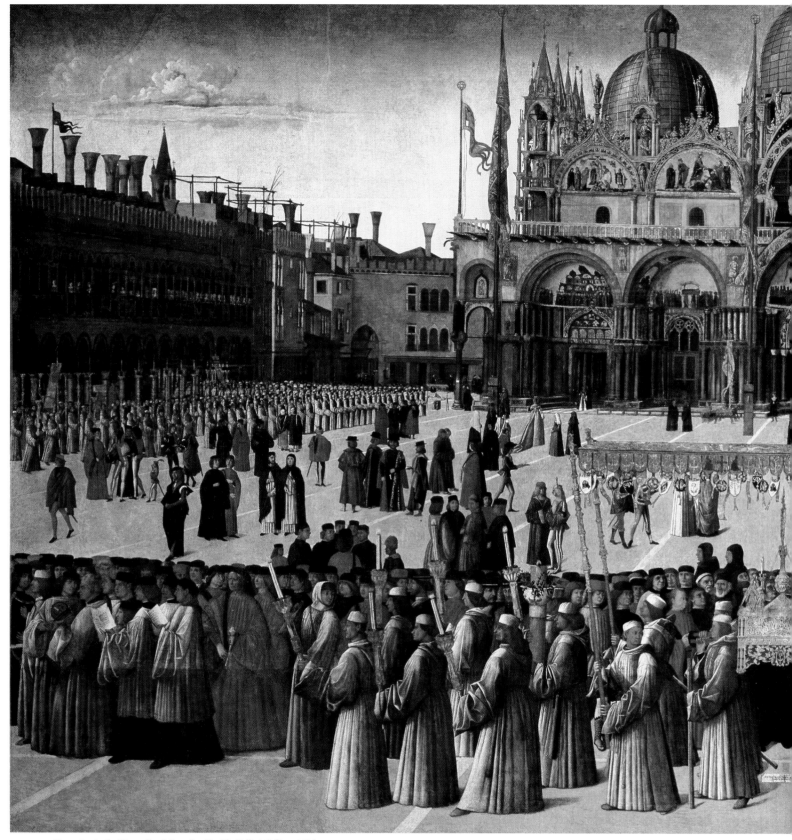

Procession in the Piazza San Marco, by Gentile Bellini, Italian, 1496

Procession in the Piazza San Marco on the occasion of Corpus Christi, the most solemn of Venice's festivals. Under the canopy, in the centre, is the gold reliquary containing a relic of the True Cross, long renowned for its miraculous powers of healing. Just behind, on his knees, a man named Jacopo de Salis prays that his ailing son in Brescia

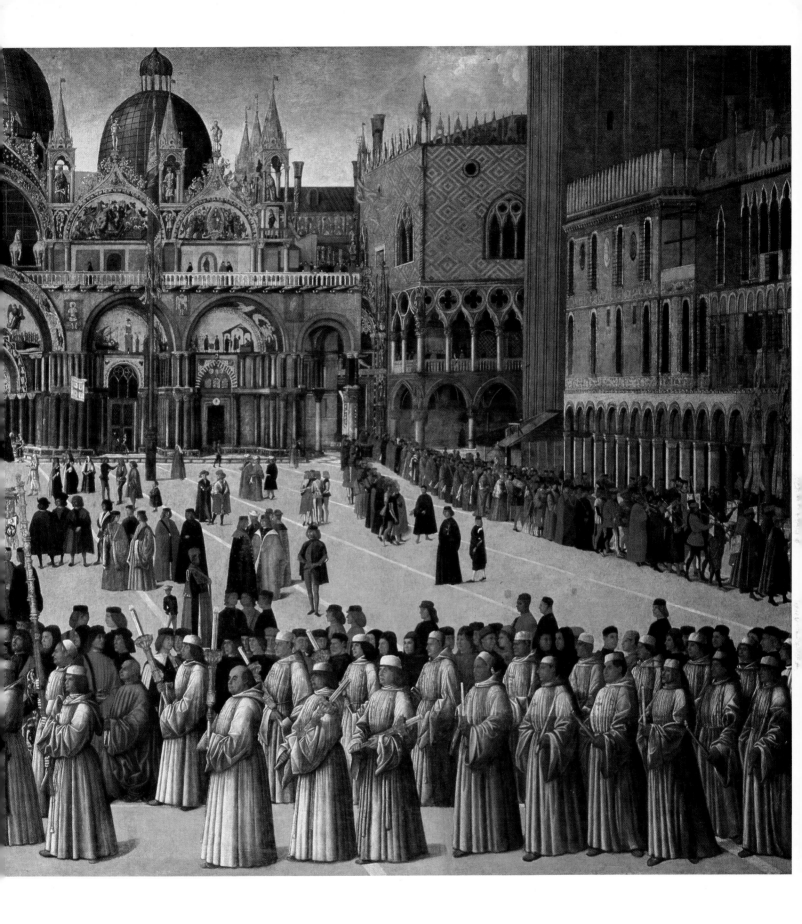

might soon be cured. Leading the procession of monks are the choristers and candle-bearers. As all move slowly through the square, the Doge and his guests watch the ceremony from his palace. Dominating the whole impressive scene is the magnificent façade of St Mark's, the Doge's private chapel.

The Egyptian soldier, wearing Italian parade armour *all'antica,* is a detail from a panel illustrating the Genesis story of Joseph. Although scholars were by now becoming interested in historical costume, and were studying ancient coins and statues, it was still customary for Renaissance painters to show classical and biblical stories in contemporary dress.

The taking of Naples. A victorious Charles of Durazzo, mounted on a white horse and with standards flying leads his men into Naples on 26 July, 1381. It was a triumphant end to his campaign – backed by Pope Urban VI – against Otto of Brunswick, husband of Joanna I, Queen of Naples. Joanna had endorsed the Avignon claimant to the papacy, Clement VII, in the Great Schism that followed the death of Gregory XI. A major attraction of the painting is the juxtaposition of toy-like buildings and giant soldiers by which the *cassone* artist makes clear that this is not just a pretty harbour scene but the record of an important victory for the new king of Naples.

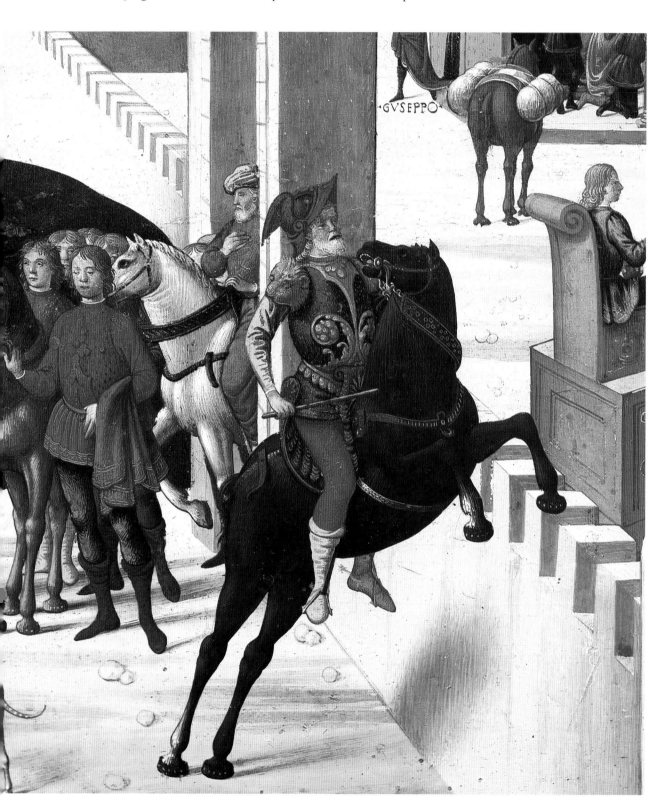

Italian cassone panel, 15th century

Italian cassone panel, 15th century

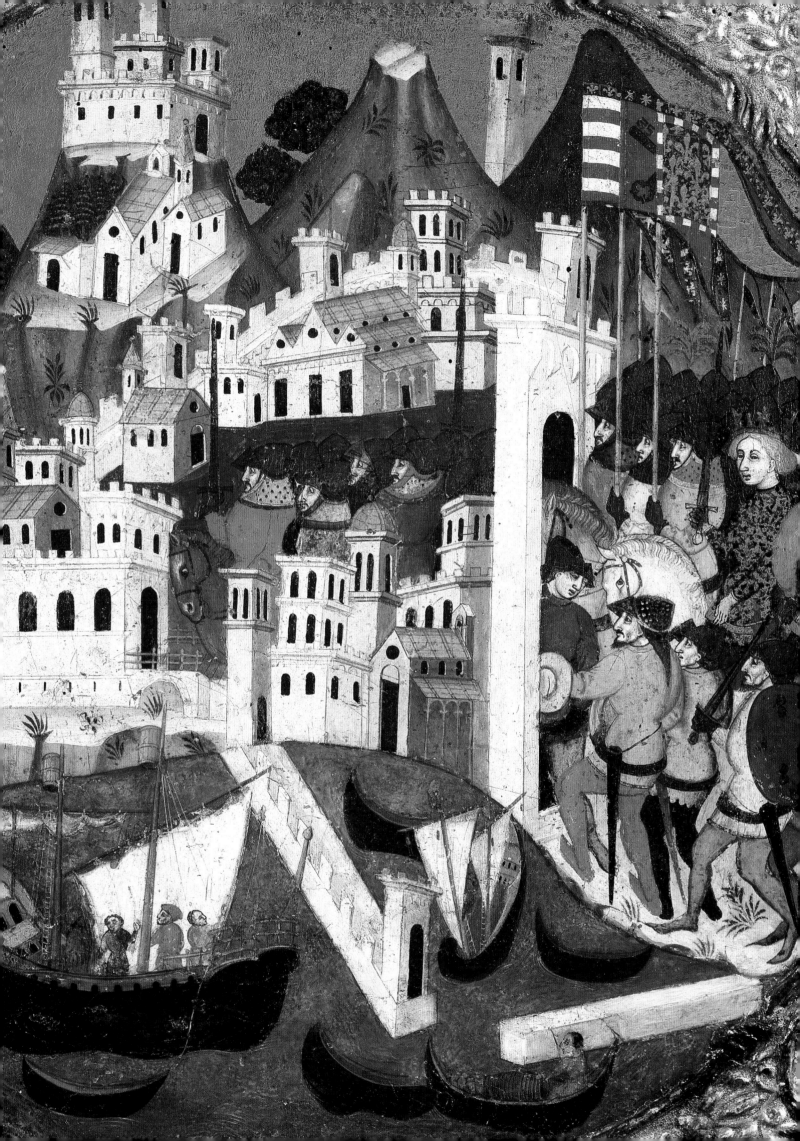

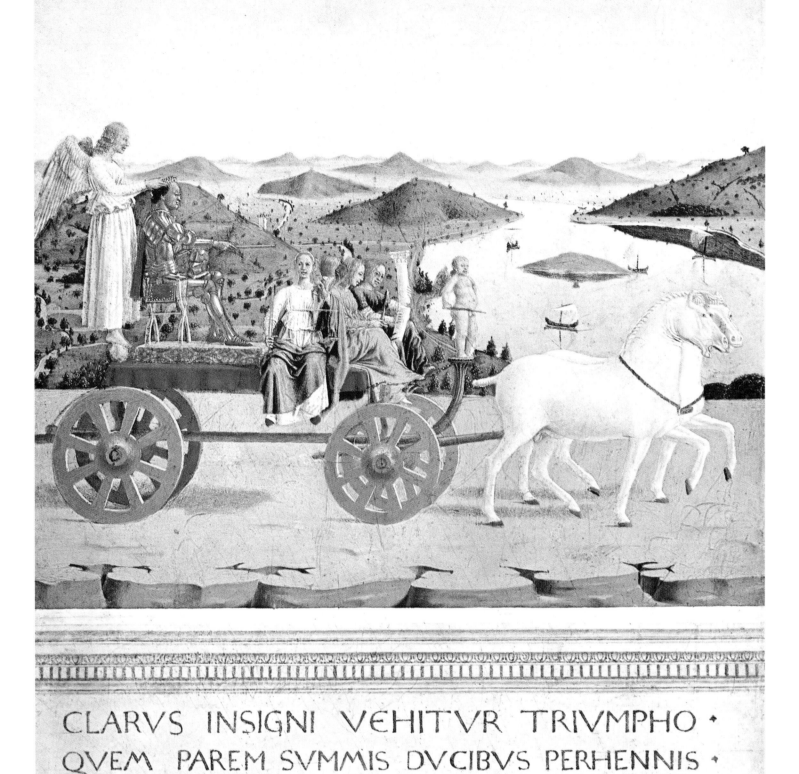

CLARVS INSIGNI VEHITVR TRIVMPHO •
QVEM PAREM SVMMIS DVCIBVS PERHENNIS •
FAMA VIRTVTVM CELEBRAT DECENTER •
SCEPTRA TENENTEM •

The triumph of the Duke and Duchess of Urbino is a prime example of the allegorical themes of antiquity in which the Florentines delighted. The scenes appear on the reverse side of the famous diptych by Piero della Francesca portraying the heads of Federico da Montefeltro and his Milanese wife Battista Sforza. On the left, Federico is crowned by Victory attended by the four cardinal virtues: Prudence, Justice, Temperance and Fortitude. The inscription reads:

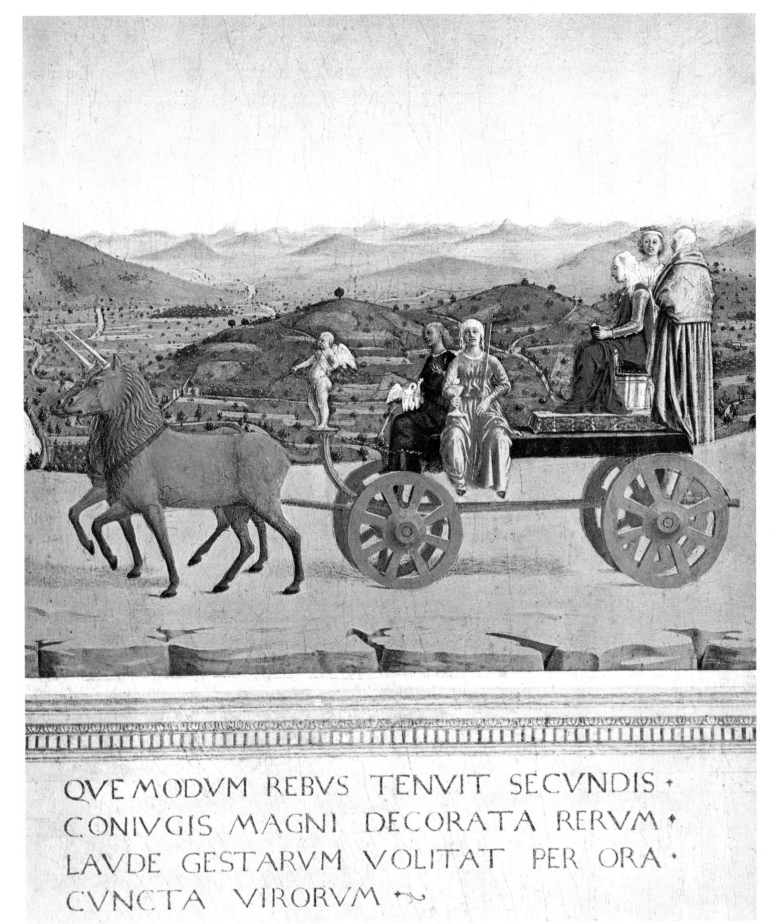

QVE MODVM REBVS TENVIT SECVNDIS ·
CONIVGIS MAGNI DECORATA RERVM ·
LAVDE GESTARVM VOLITAT PER ORA ·
CVNCTA VIRORVM

Triumph of the Duke and Duchess of Urbino by Piero della Francesca, *c.* 1465

'Peer of the greatest leaders, he is borne in regal triumph holding the sceptre nobly and glorified by the undying fame of his virtues'. Facing Federico is Battista, seated in a chariot drawn by unicorns — the favorite medieval symbol of purity.

Attending Battista are Faith, Hope and Charity. Her inscription reads: 'Even as it was with her in her great days, so she still lives on the lips of all men, adorned by the glory of her illustrious husband's deeds.'

45

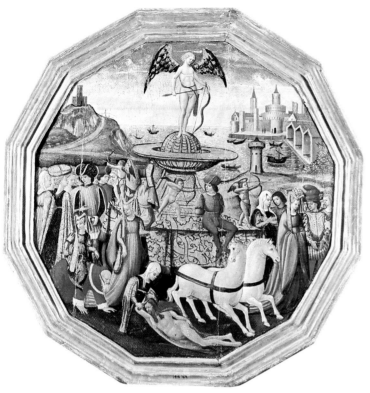

Desco da parto, Florentine, 15th century

Allegories of love

When a child was born friends would give the mother a decorated 'birth tray', or *desco da parto*. The theme of this tray is the triumph of love over the intellect. A winged Cupid, god of love, is riding in his chariot over two of love's martyrs, Aristotle, with the prostitute Phyllis on his back, and Samson, his head on Delilah's lap.

Aphrodite, ruler of the month of April, dominates the mural devised jointly by Pelegrino Prisciani, Court Astrologer to the Duke Borso d'Este, and the local Ferrarese artist Francesco del Cossa. Like his brothers Leonello and Ercole, Borso delighted not only in the building of elegant palaces, but in theatricals and pageantry of all kinds. Aphrodite, enthroned here, is on a float drawn by swans. In her hand the Goddess of Love bears the golden apple awarded by Paris, and kneeling before her in chains is her love-slave, Mars. On either bank rabbits, symbols of fertility, are gambolling while young couples respond lovingly to the glory of Spring. On the second band a male figure sits holding the key to the new season while another represents, even more esoterically, the last ten days of March.

46

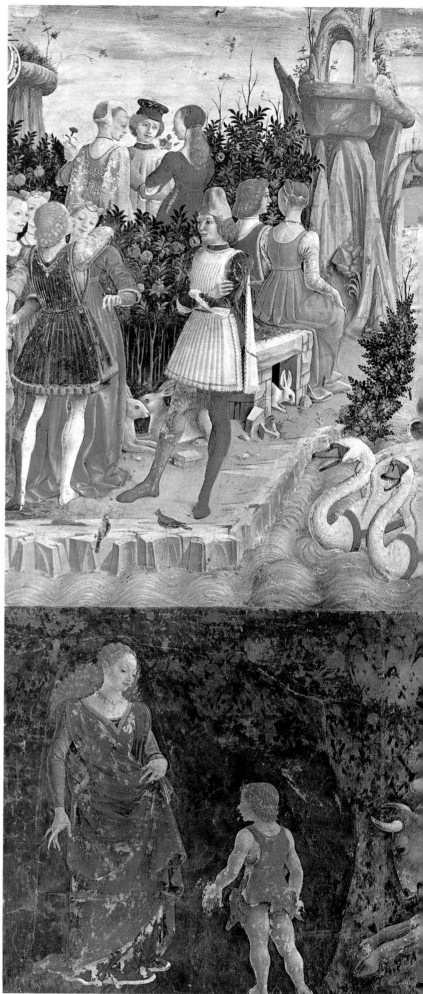

Fresco by Francesco del Cossa in the Palazzo Schifanoia, Ferrara, 15th century

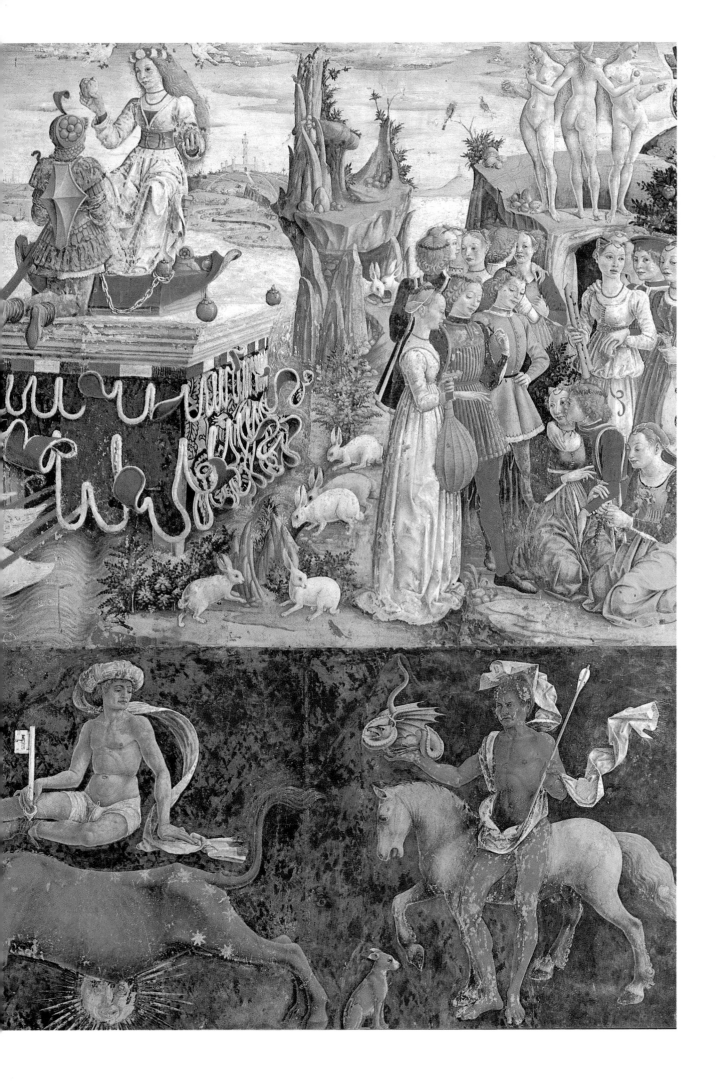

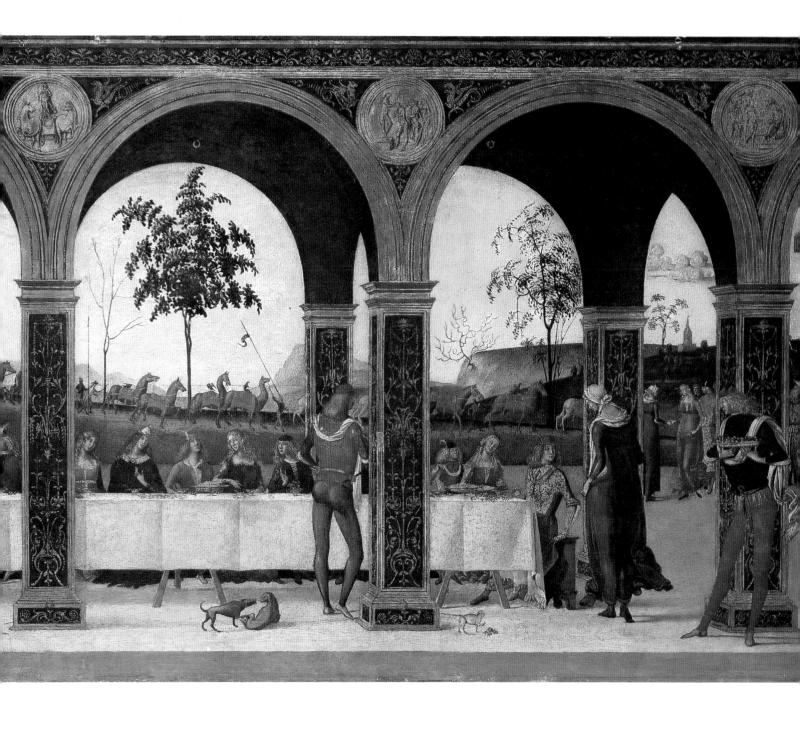

Two Renaissance women

The story of Griselda,
anonymous Italian painting,
15th century

Young man and woman at a
casement, by Fra Filippo
Lippi, Italian, 15th century

Patient Griselda. The story, recounted by
Boccaccio in the *Decameron*, tells how the fair
Griselda, married to a jealous husband, is put to
one unbelievably cruel test after another to prove
her devotion. A crucial test was to take her
children away from her and pretend they had
been killed. In the right background of this palatial
setting, with its classical architectural detailing, the
husband summons Griselda and instructs her how
she is to behave to his pretended second wife. In
the right foreground, Griselda praises two children
who her husband tells her are his. The scene on

the left is part of the final banquet when all is
revealed and the long-suffering heroine has her
reward.

Portrait of a young couple. Probably the earliest
surviving double portrait — in a true sense — and
certainly one of the most endearing ones of a
young husband and wife. The two figures fondly
regarding each other are believed to be Lorenzo
Scolari (his family's coat of arms appears under his
hands) and Angiola di Bernardo Sapiti, who were
married in 1436.

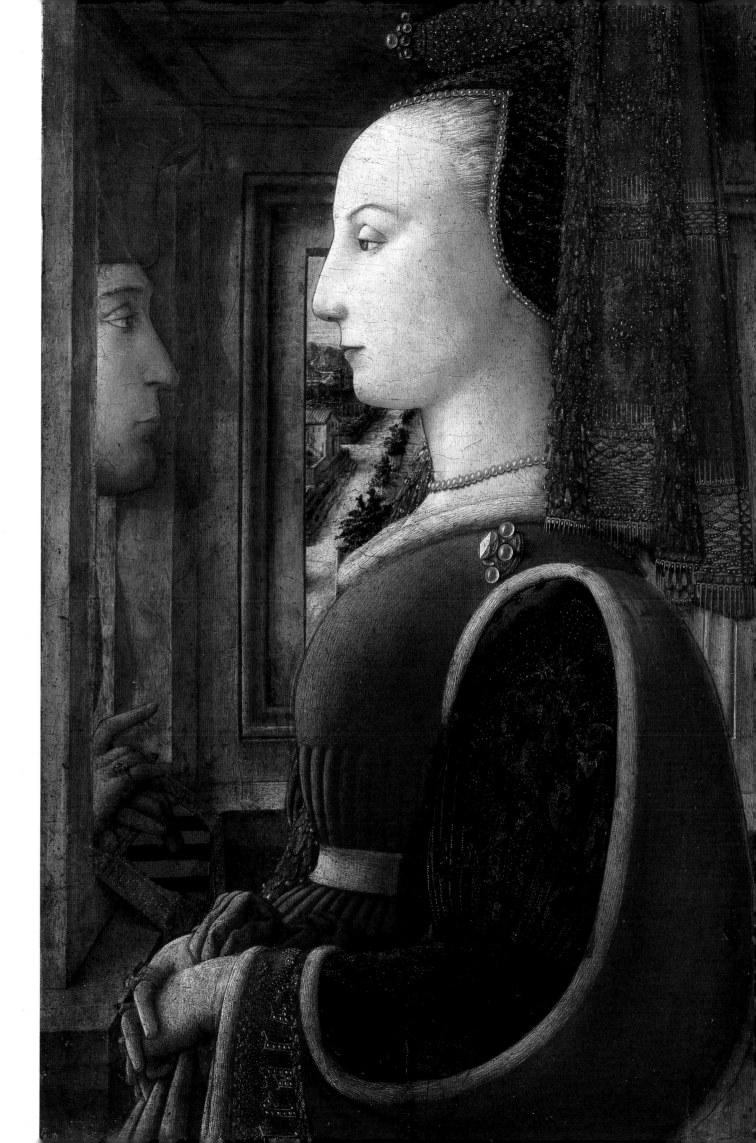

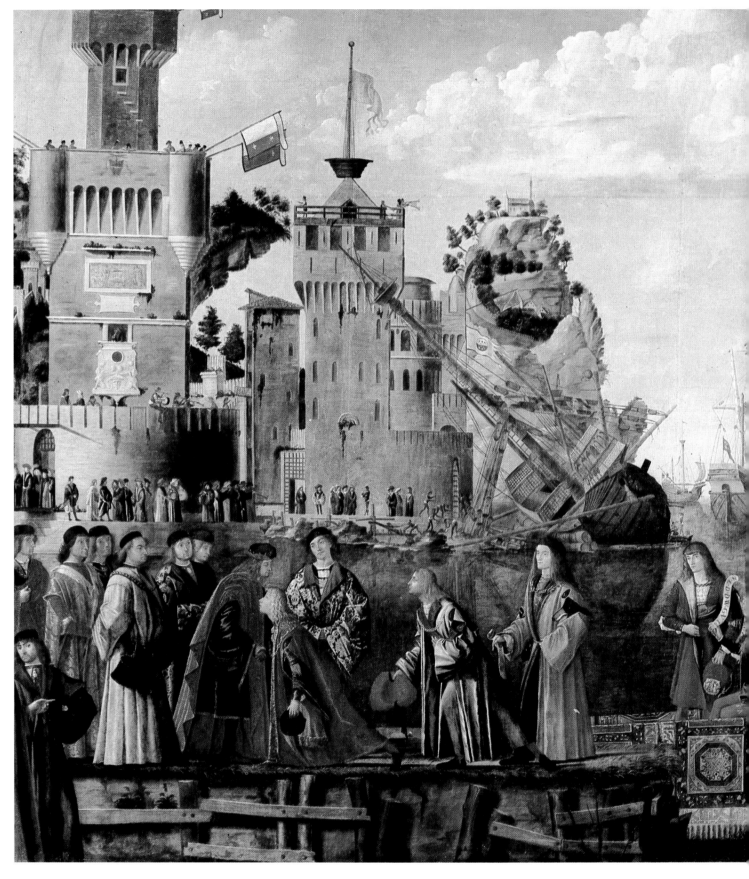

From the Cycle of St Ursula, by Vittore Carpaccio, Italian, 1495

St Ursula, daughter of the legendary King Deonotus of Brittany, was demanded in marriage by a 'pagan' English prince. According to an eleventh-century version of the story, Ursula is warned to demand a three-year reprieve from the prince, during which time she leads a pilgrimage of eleven thousand virgins to Rome. But on their

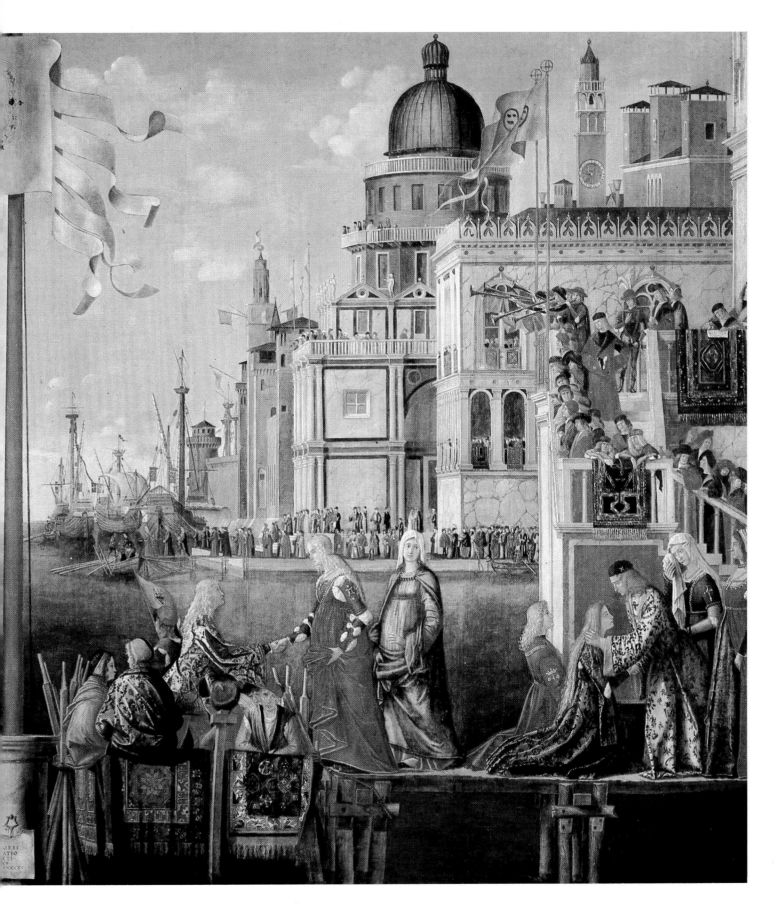

return journey down the Rhine from Basel in their 'triremes', all are attacked and massacred by the Huns in Cologne. By taking the ancient legend, greatly expanding it and setting it against the opulent background of fifteenth-century Venice, Carpaccio transformed it into a medieval pageant of magnificent proportions. He made it still more Venetian by including in some groups recognizable personalities such as members of the wealthy Loredano family. This scene (one of nine panels) shows, at left, the departure of the English prince and, at right, his reception at the home of Ursula's parents.

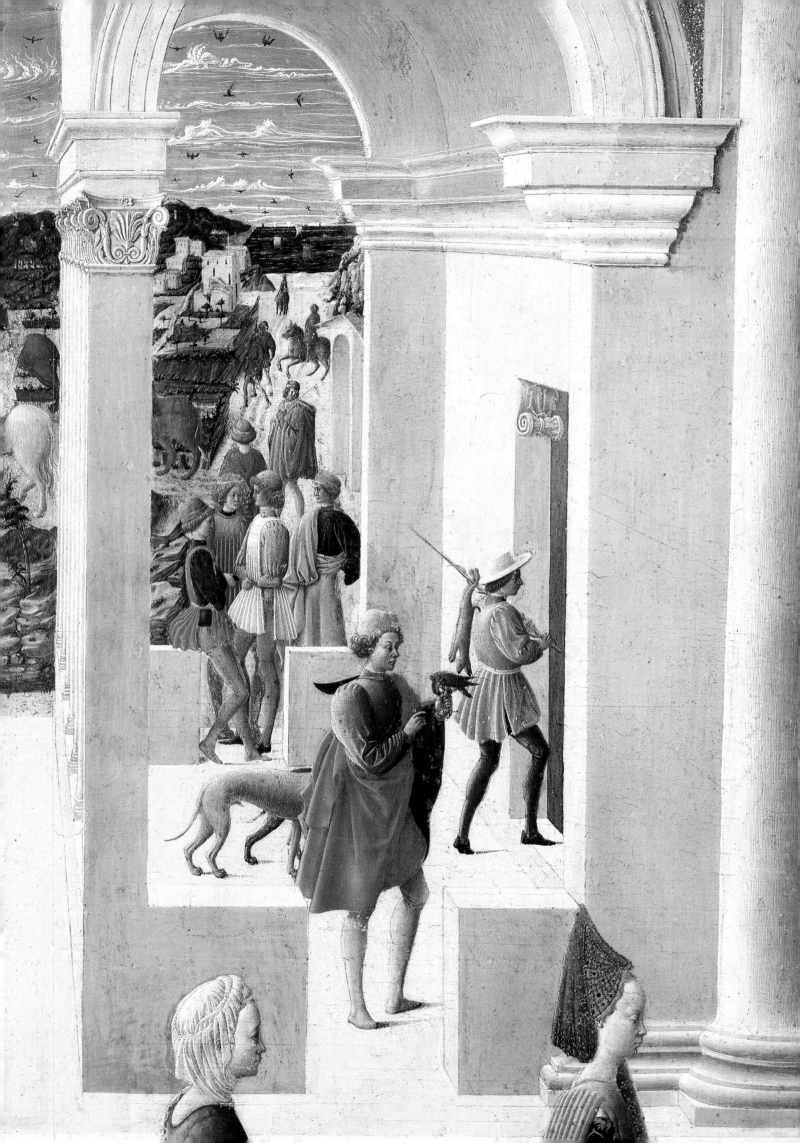

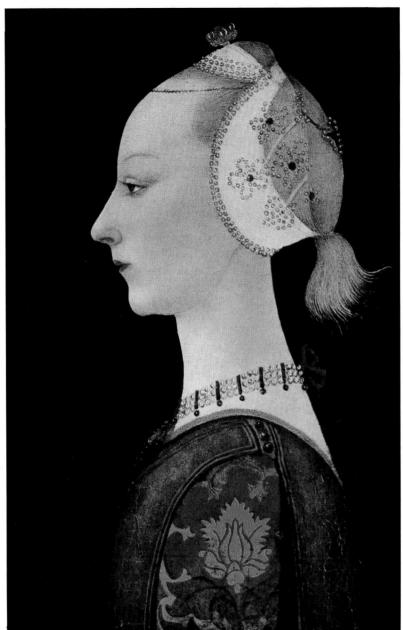

A young lady of fashion, painted in Florence towards the middle of the fifteenth century, when portraits were in great demand as symbols of wealth or noble birth. The first convention was for profiles, following the manner of the heads found on ancient Roman coins, which had recently been unearthed and were now treasured by collectors. Later, fashion dictated the full-face portrait.

The leisured life of contemporary Italian landowners often appears in the background of the devotional paintings they commissioned. In this lovely detail from a scene of the birth of the Virgin we can see the work of the farm going on in the distance, while in front aristocratic youths sit and talk in the majestic archway of a Renaissance palace. In the foreground a man carries a hare — destined for the kitchen — while another holds his falcon on his wrist.

Youth and beauty

Portrait of a lady by Paolo Uccello, Italian, 15th century

From *The Birth of the Virgin* by the Master of the Barberini Panel, Italian, 15th century

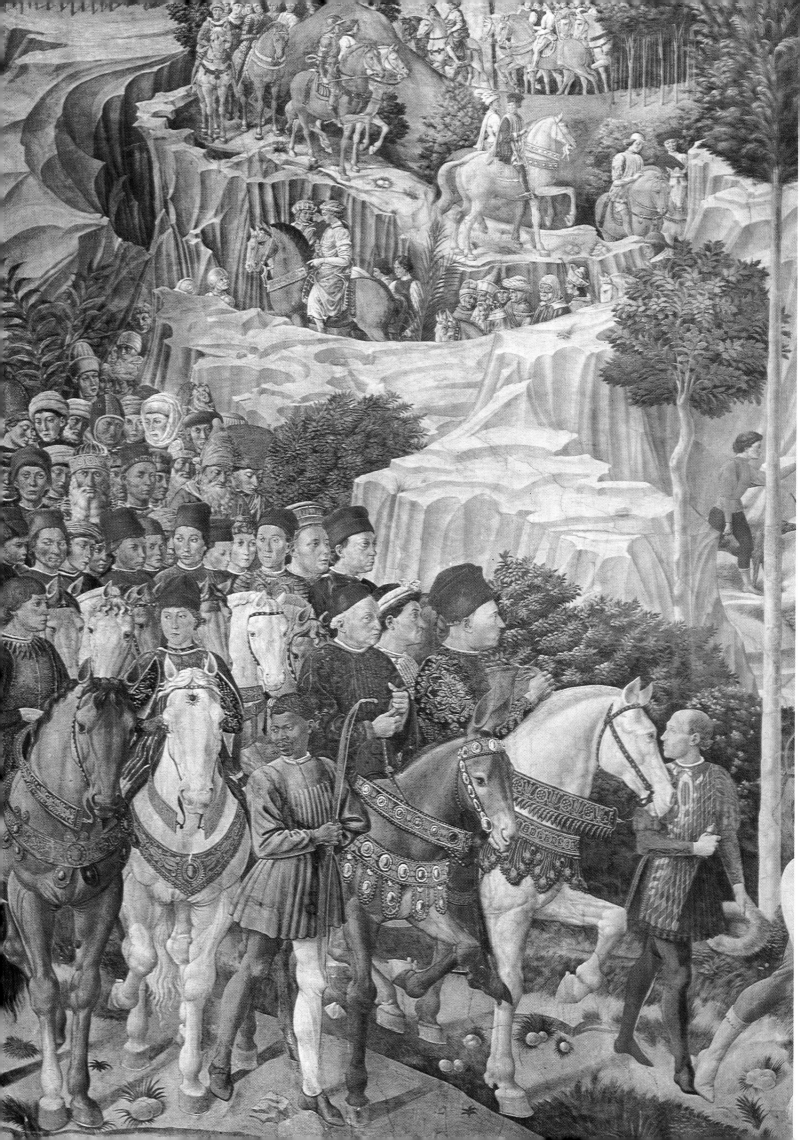

Magi and Medici

When in 1459 Piero de' Medici ordered the subject of the journey of the Three Kings to decorate a wall in his palace chapel, the artist used his patrons as models. Piero himself, nicknamed 'the Gouty', is on a white horse (*left*). His father Cosimo, *Pater Patriae*, dressed in blue and riding a mule, is seen behind the African page. The artist

Benozzo Gozzoli included a small self-portrait (toward the back, at left, behind two bearded dignitaries) with the words *Opus Benotti*, (work of Benozzo), written across his red cap. The king on the white horse (*below*) is a portrait of the Byzantine emperor John VI Palaeologus, who was in Florence for an ecclesiastical council.

Journey of the Magi, details from the fresco by Benozzo Gozzoli, Italian, 15th century

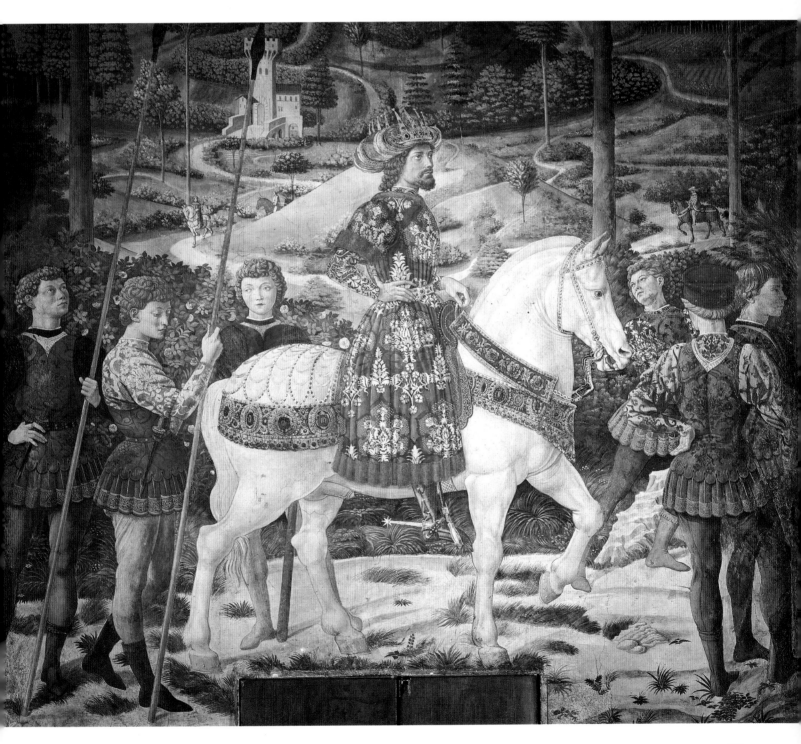

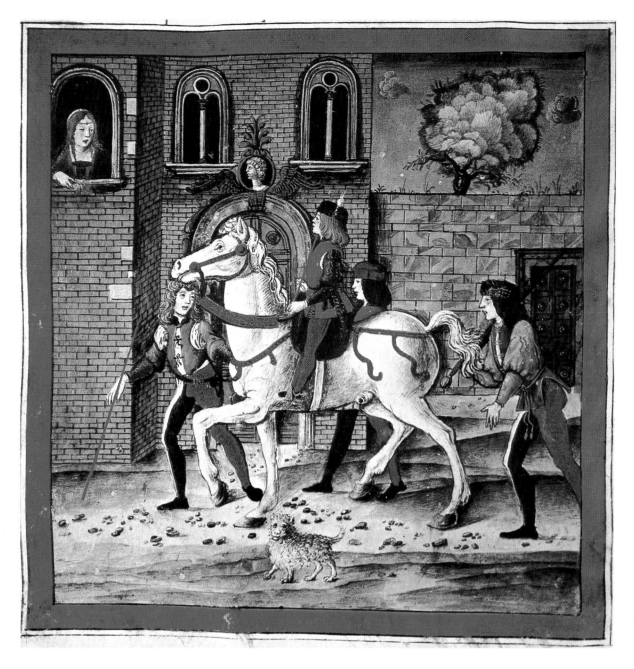

Maximilian Sforza, from an Italian 15th-century manuscript

Portrait of a Florentine youth by Sandro Botticelli, Italian, late 15th century

The dictates of fashion

Maximilian Sforza, son of Beatrice d'Este and Lodovico Sforza, the grandest Milanese prince of the Renaissance and patron of Leonardo da Vinci, is seen here riding through the streets of Milan. The announcements of his birth in 1493 had set bells ringing for six days of celebrations. But within six years his father had lost the Duchy of Milan to King Louis XII, and was to die a prisoner in France at the Château of Loches in 1508. Four years later Maximilian, supported by the pope and with the aid of Swiss mercenaries, managed, albeit briefly, to regain the duchy for the Sforzas. He is depicted above as 'the ideal young gentleman', the lady gazing out of the palazzo window bearing out the inscription which appears in the original manuscript: 'All the ladies watch him and are in love with him.'

Opposite: **A Botticelli portrait** of a Florentine youth whose dress and fashionable length of hair are similar to Maximilian Sforza's above. Botticelli, pupil of Fra Filippo Lippi, entered the service of the Medici in 1474, producing for Lorenzo two of the most famous canvases in the world: the *Primavera* and *Birth of Venus*. Towards the end of the fifteenth century, when Lorenzo de' Medici died and his weak son Piero was expelled, a reaction against this joyful paganism set in. The Florentines made a bonfire of their 'vanities' and it seemed to Botticelli that his whole world had collapsed. But he lived on, partly won over by Savonarola's violent brand of puritanism, though in increasing loneliness and isolation, till the age of seventy-two.

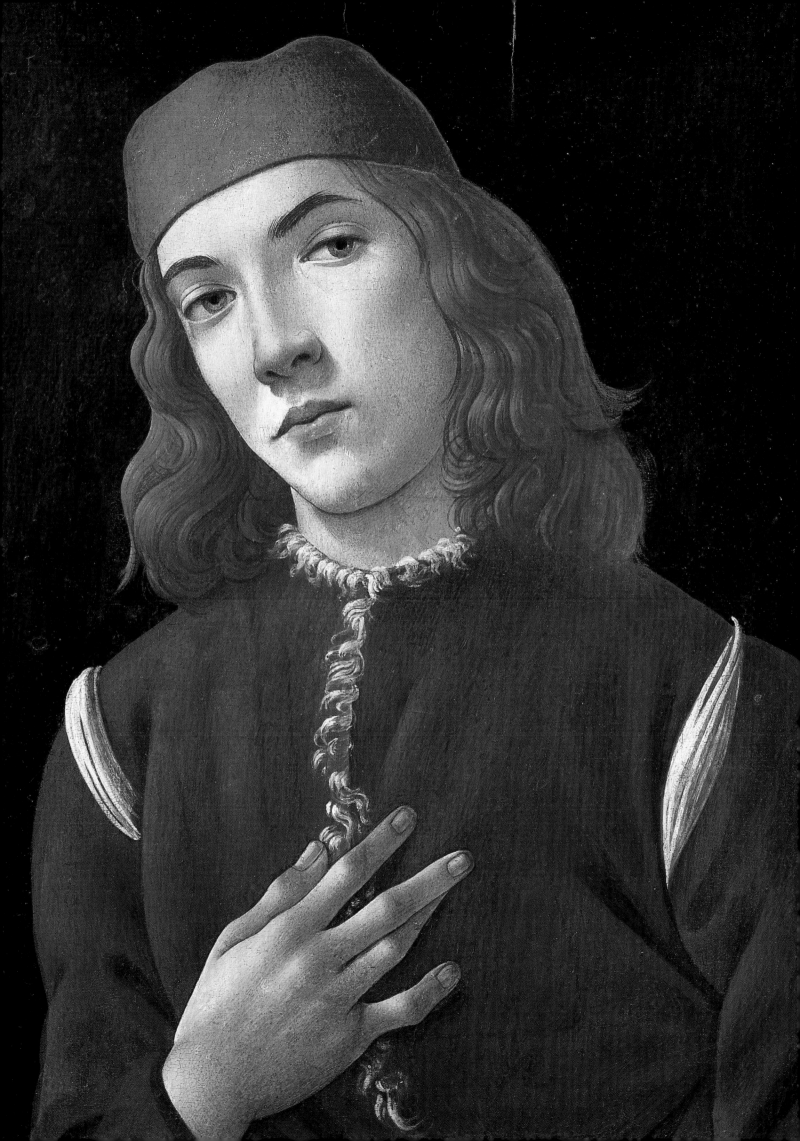

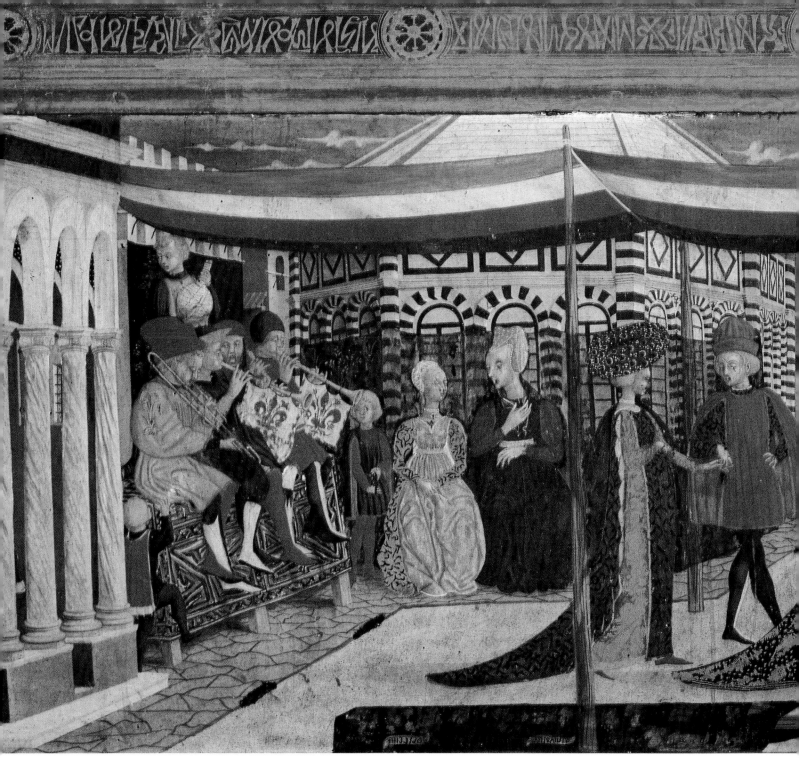

Panoply of marriage

A wedding reception in a square outside the Baptistery of Florence. The occasion was the marriage of Boccaccio Adimari to Lisa Ricasoli. In a dazzling display of costly silks, brocades, velvets and damask, the immaculately dressed guests walk two by two under a striped canopy to the accompaniment of trumpets. The men's parti-coloured hose, capes, tabards, hoods and caps are as rich and colourful as the ladies' cloaks, gowns and head-dresses, one of which sports a mass of peacock feathers. Florence under the Medici family

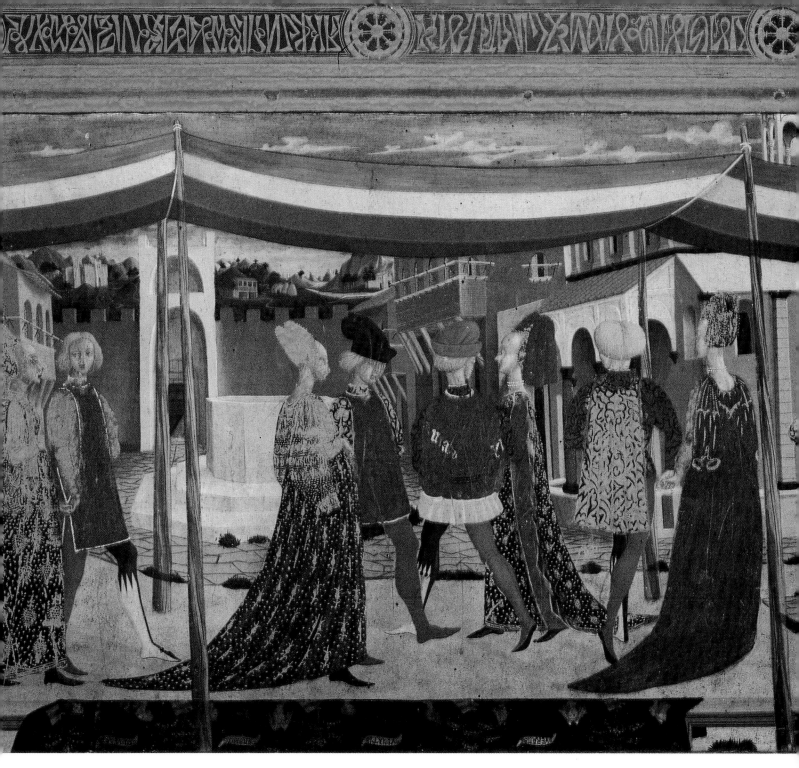

Cassone Adimari, Florentine, 15th century

reached the height of its power and glory. At one point weddings had become such extravagant affairs that the authorities tried to pass laws limiting the amount that could be spent on an outfit, allowing no more than twenty-five guests to attend the wedding feast and reducing the meal to a modest three courses. Such laws were almost impossible to enforce and no one paid very much attention, at least until the end of Medici rule and the rise of Savonarola, when Florentine life was to become puritanical and austere.

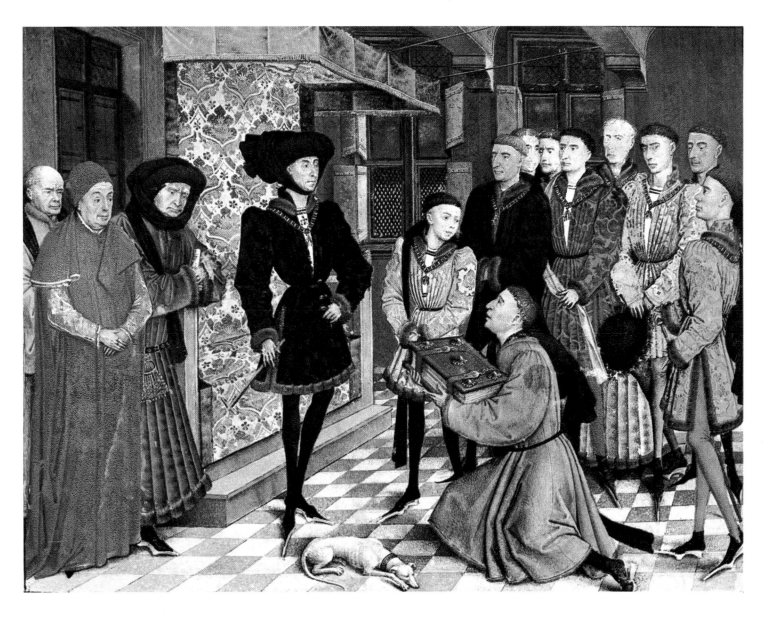

The Golden Age of Burgundy

Philip the Good was Duke of Burgundy from
1419 until his death in 1467. Through inheritance,
marriage, political manœuvring and conquest
Philip came to possess virtually all the Low
Countries and a large part of northern France.
This made his duchy the wealthiest power in
Western Europe and increasingly a renowned
centre of art and culture. Philip, a great art patron
himself. lived in the castle of Hesdin and presided
over the most brilliant and fashionable of courts.
Here, Jean Wauquelin is presenting him with a
copy of the *Chroniques de Hainault*, while on one
side of him stands Chancellor Nicolas Rolin,
patron of Jan van Eyck, and on the other, his
young son, the future Charles the Bold. Around
Philip's neck is the insignia of the Golden Fleece,
an order dedicated to chivalry and the church,
which he had founded in 1446. The duke
supported the English in the Hundred Years' War

up until 1435, when he switched sides and made a
profitable treaty with Charles VII. Philip once said
his lifelong regret was that he had not, at the age
of nineteen, fought by the side of Henry V at
Agincourt.

Opposite: **The Flemish knight** Anthony of
Burgundy, most famous of the illegitimate sons of
Philip the Good, was painted by the great Rogier
van der Weyden, who shows him wearing the
emblem of his father's Order of the Golden
Fleece. Among Anthony's many accomplishments
was his consummate skill in the lists. In the
summer of 1468 in Bruges, he organized the
grand tournament of the Golden Tree, celebrating
the wedding of his half-brother Charles the Bold
to Margaret, Duchess of York, sister of King
Edward IV.

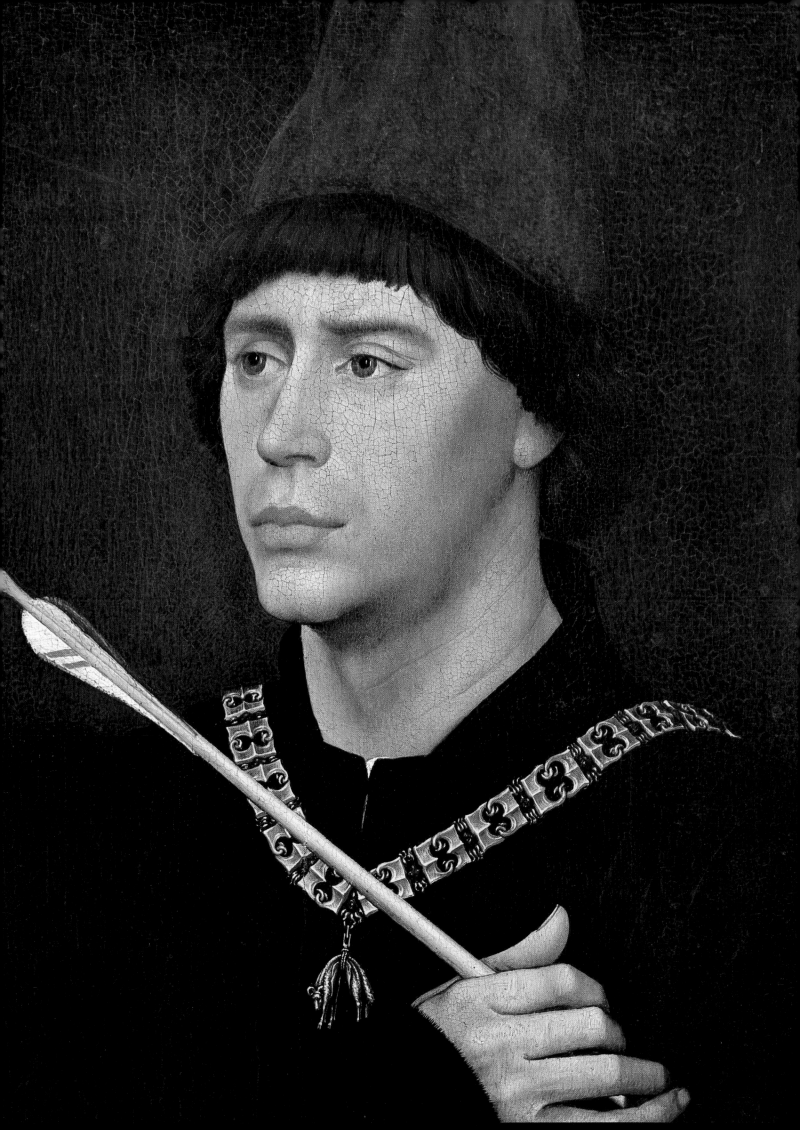

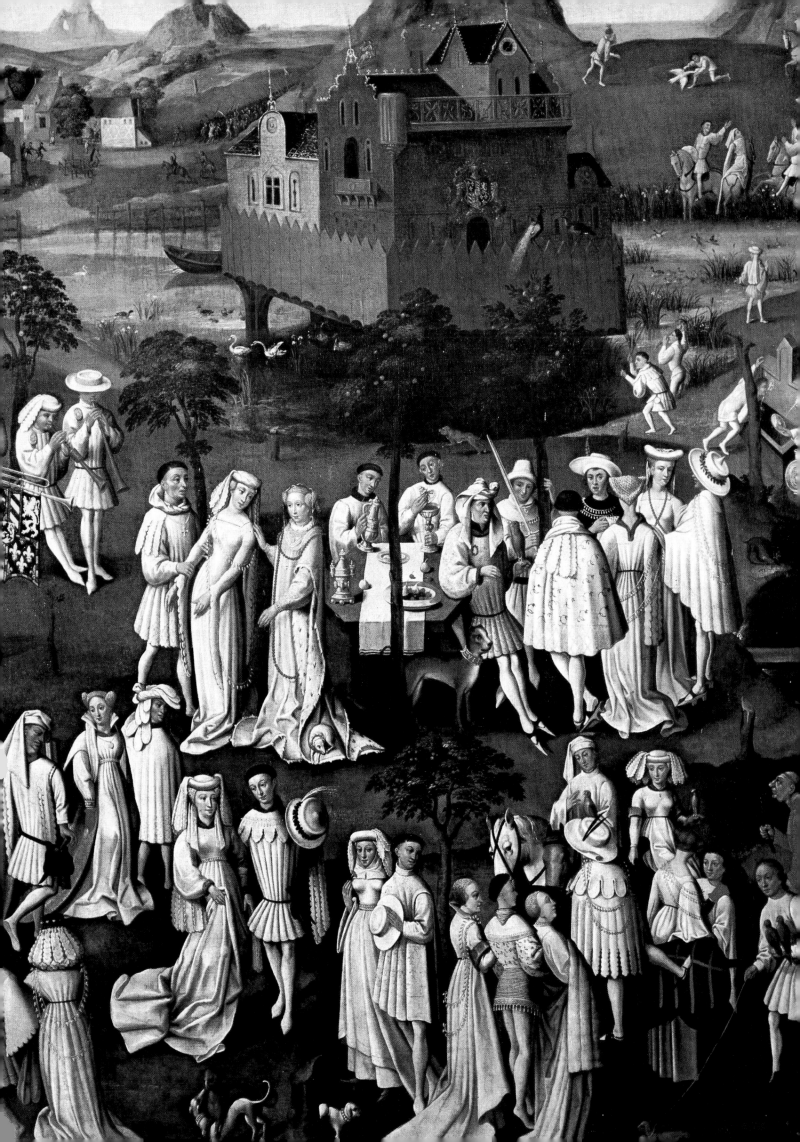

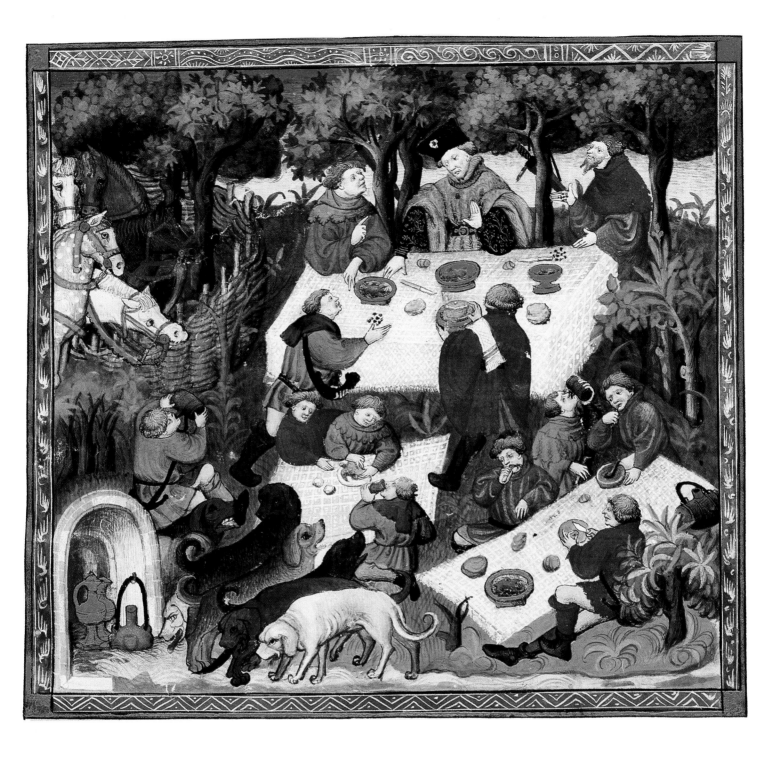

Outdoor pleasures

All-white picnic following a falconry expedition, staged by an impeccably dressed Burgundian court when organ-pipe pleats were the height of fashion. The occasion was the eve of Philip the Good's marriage to his third wife, Duchess Isabella of Portugal. Philip chose his wedding day, 7 January 1430, for the founding of his Order of the Golden Fleece.

A hunter's picnic, before 'slipping the hounds'. The picture is from a book on hunting by Gaston III, Count of Foix and Béarn. The count, also known as 'Gaston Phoebus' because of his red-gold hair and good looks, was a man of such fierce passions that he even went so far as to kill his only legitimate son in a fit of unbridled rage. His greatest interest, the hunt, resulted in the treatise which he wrote in the Pyrenees. The 'master' at the head of the picnic table is thought to be the count's likeness.

Picnic at the Court of Burgundy, 16th-century copy of a lost Flemish original by the School of Van Eyck

The Gathering before the Stag Hunt, by Gaston Phoebus, French, c. 1407

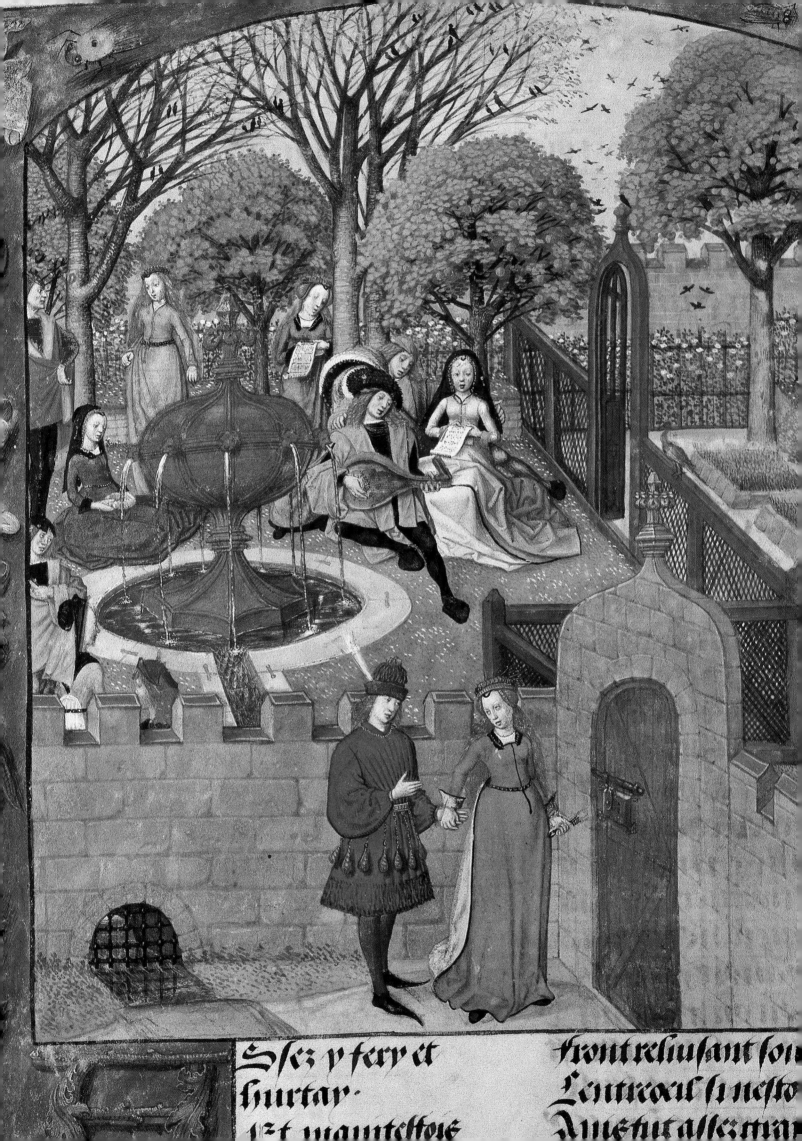

Sser y ferÿ et
huretar.
Et manteffoie

front reliufant fou
l entreail finesto
Auenit alsemar

Carola in the garden, from a manuscript of the *Roman de la Rose* attributed to the Master of Juvenal des Ursins, Flemish, 15th century

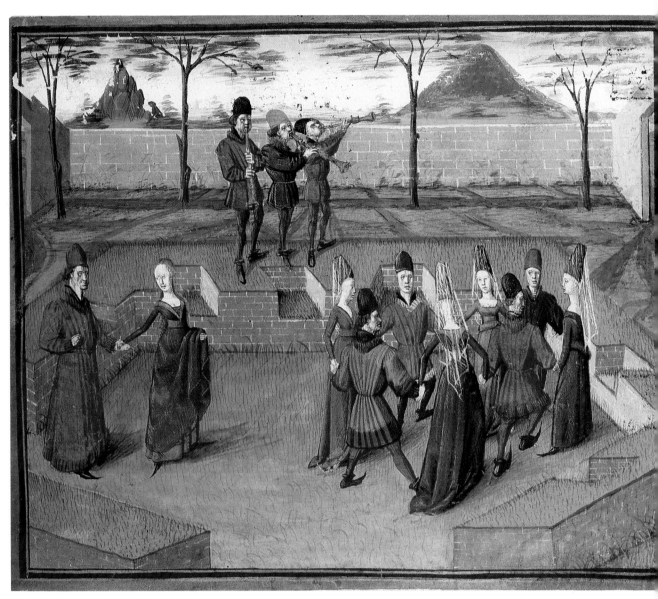

Illumination from a Flemish 15th-century manuscript of the *Roman de la Rose*

Gardens of love

The Roman de la Rose, the long and immensely popular allegorical poem written in the thirteenth century by Guillaume de Lorris and Jean de Meung, is at once the culmination and the end of the courtly love tradition. The beloved is symbolized by the rose, growing in an enclosed garden, to which the lover has to be admitted through a locked door. These two illustrations are from fifteenth-century manuscripts. The philosophy of courtly love is thought to owe much to Eleanor of Aquitaine, who was well versed in Ovid's *Art of Love* and certainly well acquainted with the legends surrounding King

Arthur and Camelot. But it was mainly the troubadours, with their lyrical tributes to love, honour and loyalty, that inspired her to introduce these ideas at court, first of all in France, then in England (1154) after her marriage to Louis VII had been annulled and her new husband, the Duke of Normandy, was crowned Henry II. But when Henry became involved with Fair Rosamond, Eleanor returned to France and at Poitiers founded her famed Court of Love, where affairs of the heart were aired and amorous conduct fairly judged. 'True love', the court maintained, 'must be free, it must be mutual, it must be noble.'

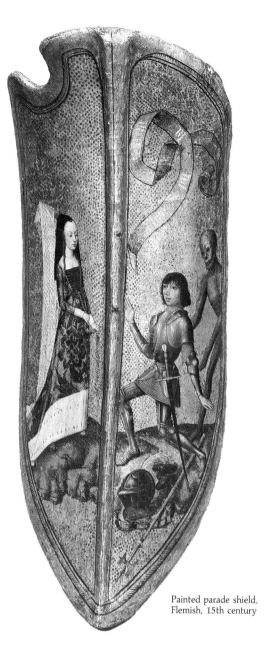

Painted parade shield,
Flemish, 15th century

The celebration of love

'Vous ou la Mort'. Once in a very long while, a knight might abandon the customary heraldic device on his parade shield in favour of a romantic scene such as this. *Vous ou la Mort* reads the scroll, while an image of death hovers in the background.

A feast in honour of the bride, Clarisse de Gascoyne, who sits demurely under a baldaquin with a maid of honour on either side. The carver has served pheasant, and as the musicians play on their shawms, filled plates are carried to the lords dining at the side table. On the left, the cupbearer passes a ewer from the sideboard to a servitor wearing a green puffed-sleeve doublet. No utensils are to be seen. Although the occasional knife or spoon might be provided on such occasions, forks were not in general use and dogs, such as the confident greyhound here, awaited the bones and leftovers tossed to the floor.

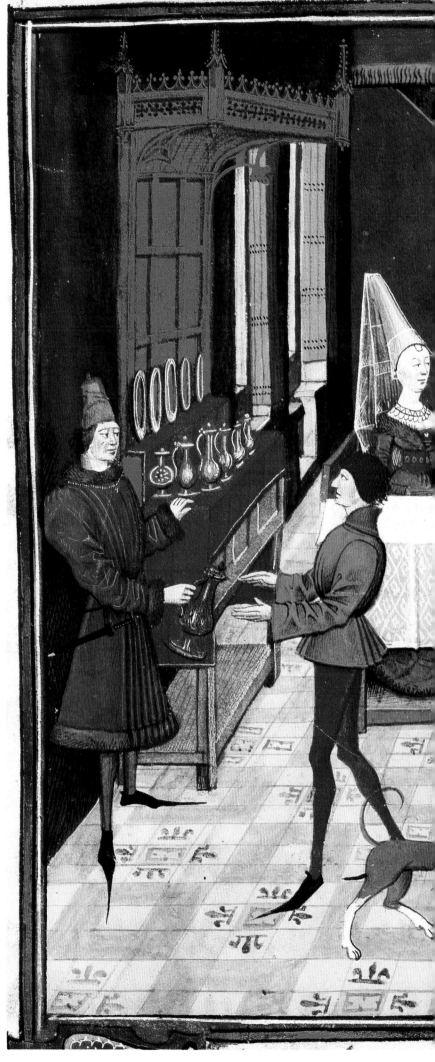

Illumination from the *Histoire de Renaut de Montauban*, French manuscript, *c.* 1462, illuminated by Loyset Liédet

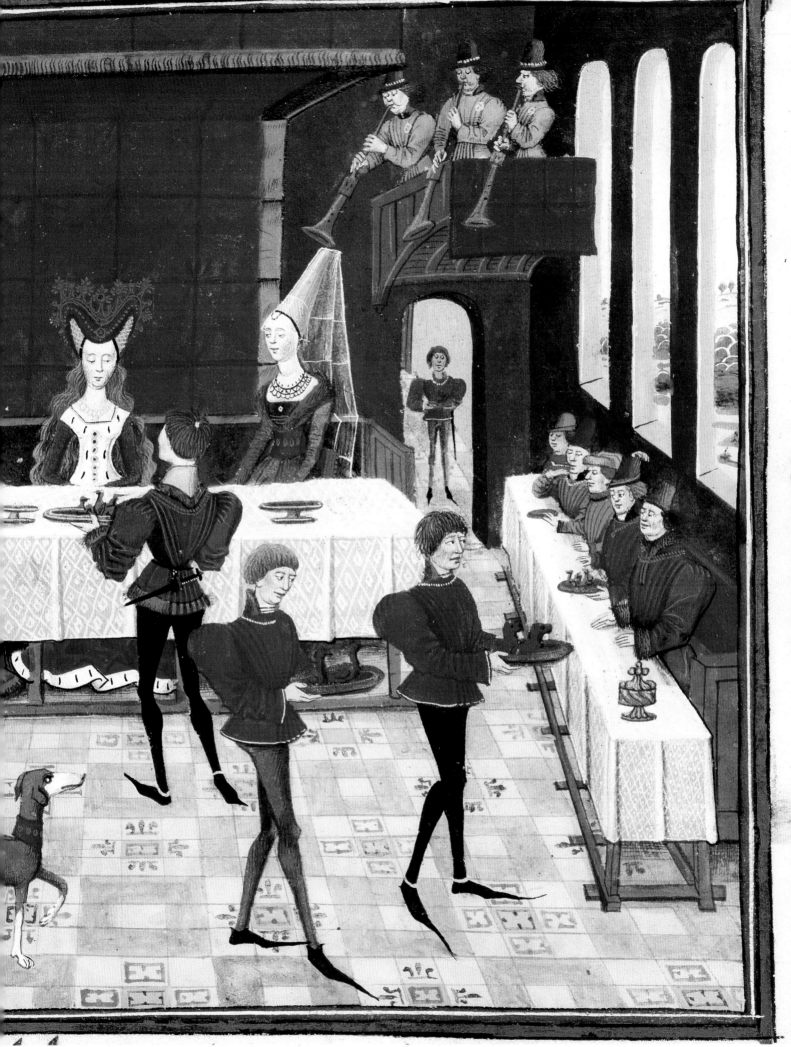

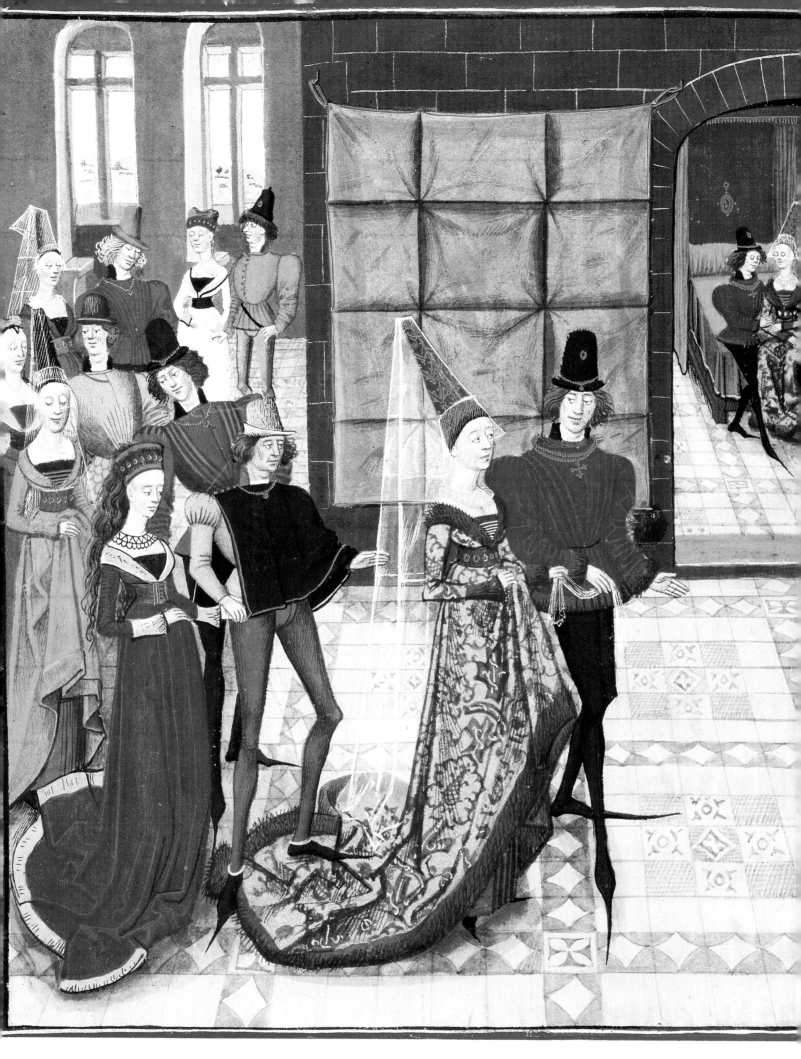

Illumination from the *Histoire de Renaut de Montauban*, French manuscript, c. 1462, illuminated by Loyset Liédet

Bride and groom. The chronicle of the young knight Renaut de Montauban, greatly prized in Philip the Good's library, remains one of the most beautifully illustrated chivalric romances of the Burgundian period. Renaut's bride, Clarisse de Gascoyne, seen at the feast on the previous page, appears again here, first as Renaut leads her across the threshold — tempting one of the guests to plant a mischievous foot on her train — then in a second scene, alone with the bridegroom in the bedchamber.

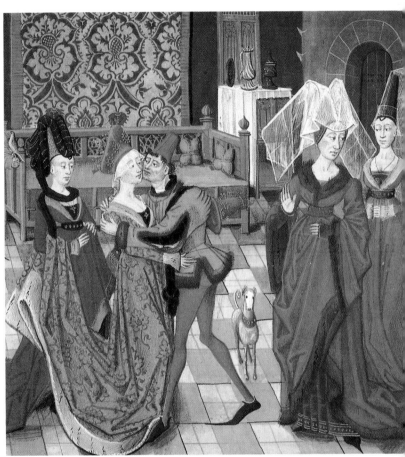

Illumination from the *Histoire de Helayne*, French, 15th century

The knight bids his lady farewell. In Europe's warring and politically violent Middle Ages, husbands and wives had often to part, and a lover's farewell might so easily be for the last time. Here the lady, Helayne, wears a brave face as her knight kisses her a fond adieu.

The Count of Roussillon

The story of Count Girart de Roussillon has come down to us in a beautifully illuminated manuscript of 1448. The miniature below shows his marriage to Berthe, the daughter of the Count of Sens. *Right*: the couple wait outside the bedchamber of the king of France. Without the poetic liberty taken by the artist in presenting Charles VII and his queen, Mary of Anjou, lying comfortably in bed with their crowns on, the picture would lack much of its great charm. The Roussillons, after losing all their children, founded in their memory twelve churches honouring the twelve apostles.

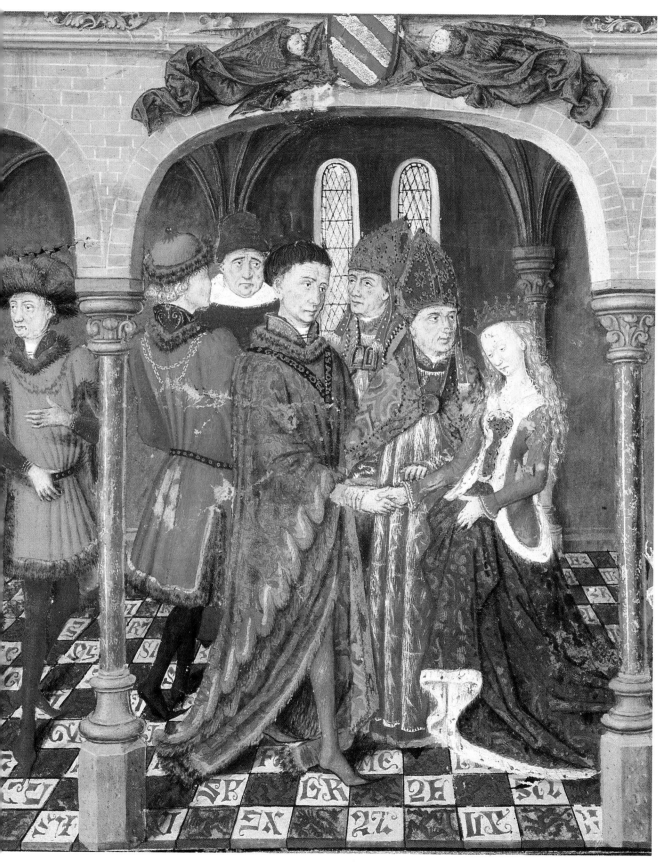

70

Illuminations from the *Roman de Girart de Roussillon*, Mons, South Netherlands, 1448

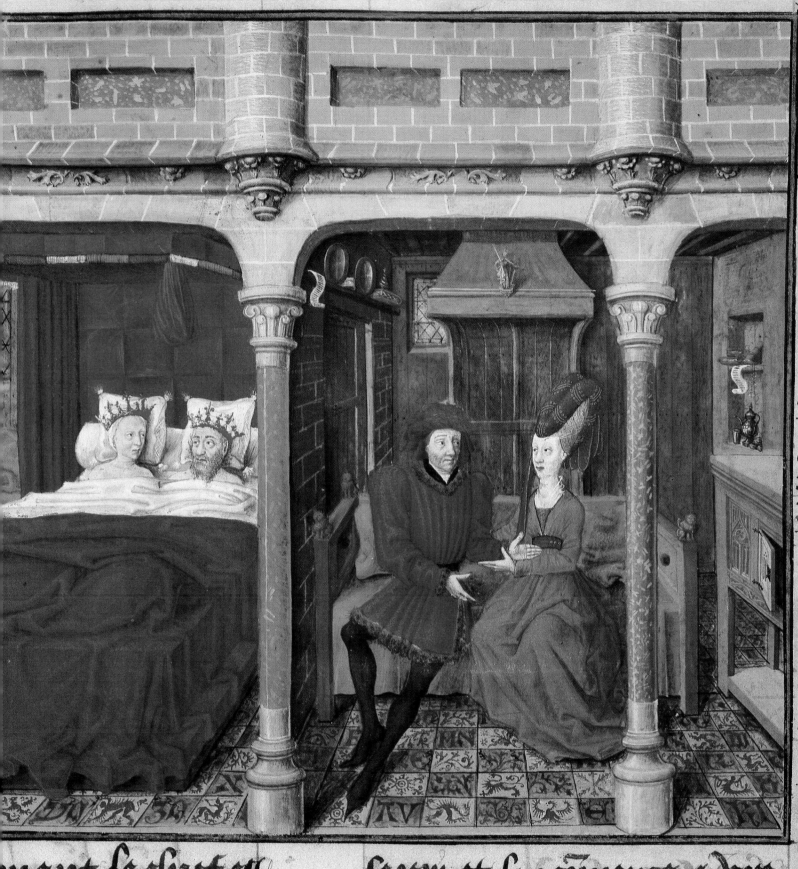

quant le chief est
aussi sont tous
. Comment la
pta au roy unes
lle auoit somp
e disoit lui chir

le roy et lui comença a dire
en ceste maniere ou sembla
ble. Tresredoubte sire moult
me merueille dont ce me vient
que en mon dozmant troye
mayntenant unit moult

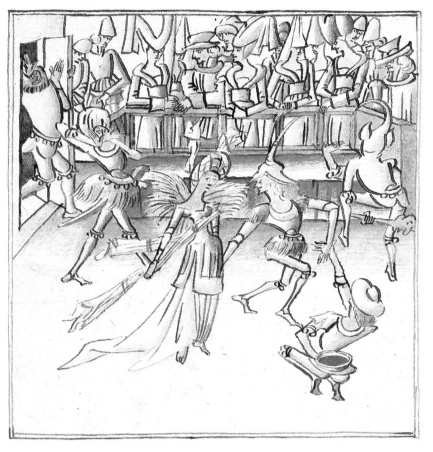

The satirist's eye

Moresca, an outlandish dance performed by energetic male and female actors to a packed gallery. In the fifteenth century, as in any day or age, earthy comic relief always found its avid followers.

Allegory of four marriages makes fun of the royal game of matrimony in which whole new territories could be acquired through angling in international waters for the best political 'catch' of the day. The central figure is Jacoba of Bavaria, Duchess of Hainault, Holland and Zeeland, seen at left surrounded by her entourage. Opposite Jacoba and standing to the right is her father, Count William VI, with the four successive spouses Jacoba acquired in record time between 1415 and 1434: John of Tourraine, Dauphin of France, John IV, Duke of Brabant, the Duke of Gloucester and Frank de Borselen.

Moresca, drawing from the *Histoire du Chevalier Paris*, French, 1464

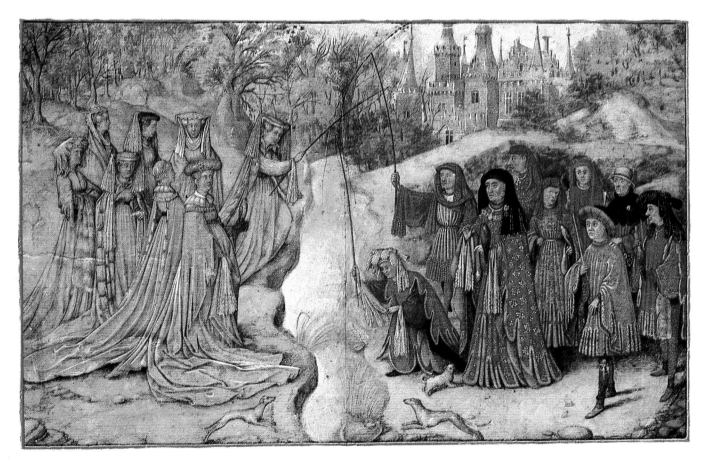

The Four Marriages of Jacoba of Bavaria, School of Van Eyck, Flemish, 15th century

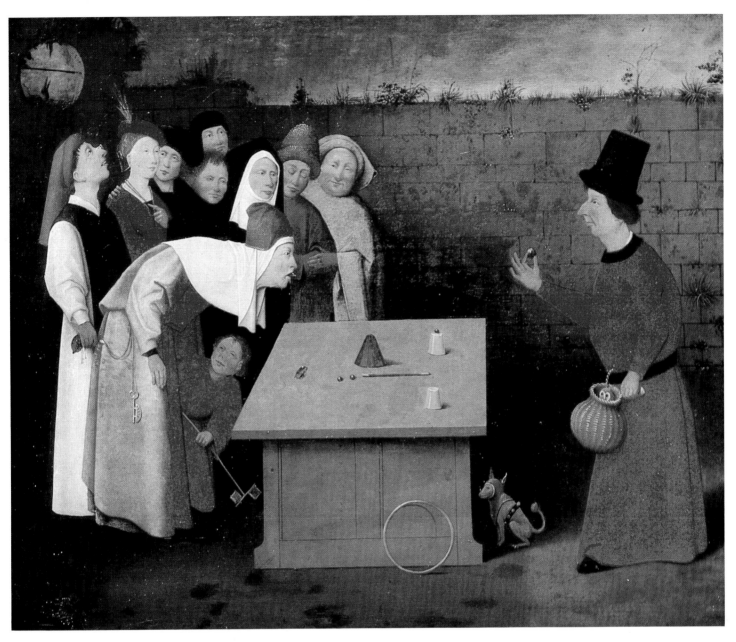

The Juggler by Hieronymus Bosch, Dutch, late 15th century

Jugglers or conjurers, were popular entertainers in the Middle Ages, along with acrobats, contortionists, mimers, clowns, minstrels and others. And at court there was the king's jester whose act depended on wit, humour and diplomacy, all three in just the right balance for him to be sure his head would remain safely on his shoulders. In the scene above, as in all paintings by Hieronymus Bosch, there is more going on than at first meets the eye. The conjurer has so riveted the attention of the stoutest of his audience that the scoundrel directly behind the bending figure, while gazing innocently upward over the top of his spectacles, relieves him of his purse. Strictly speaking, there were no 'pickpockets' in these days because few had pockets to pick, only sacks, bags, or other small receptacles to hold their coins.

Solid comforts

On a cold January night, a blazing fire to sit by and the comfortable thought of dinner! On festive occasions the overhead candelabra might be filled and lit, but in the average thrifty household the firelight and the single lighted candle served for all practical purposes.

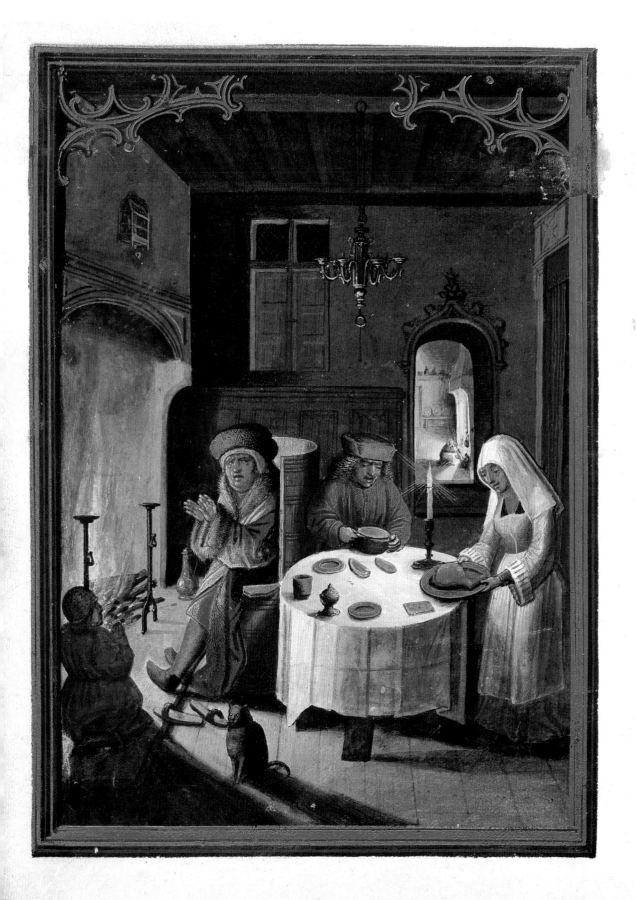

Illumination from a manuscript of Aristotle's *Ethics*, French, 1451

Illumination from the *Da Costa Hours*, Flemish, *c.* 1515

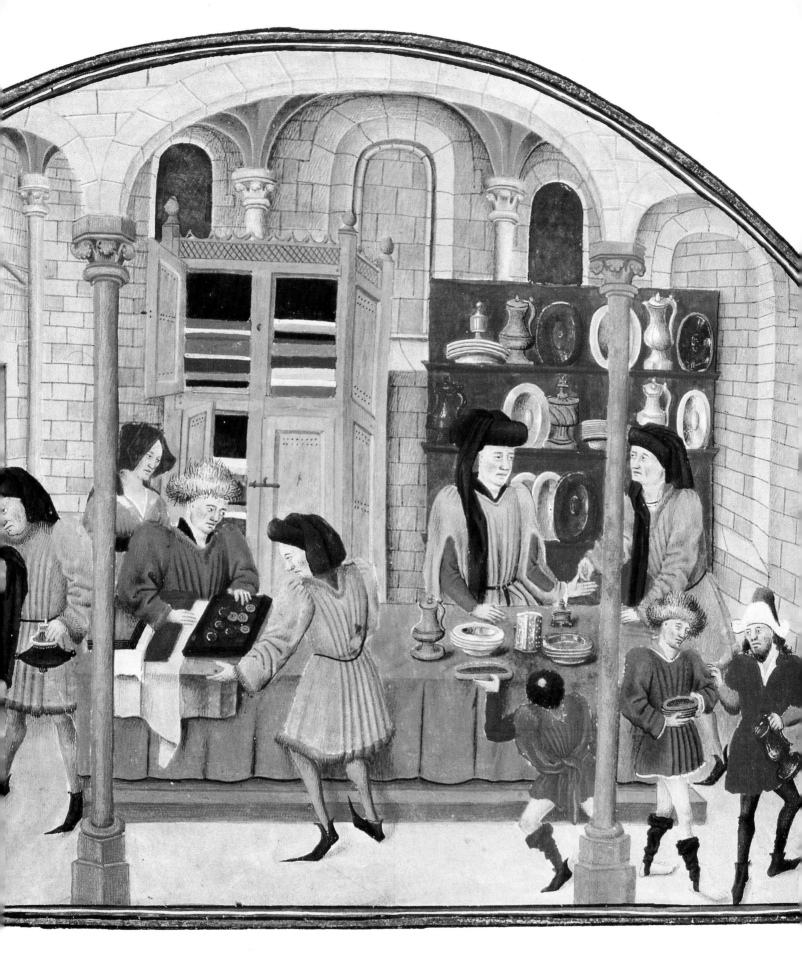

Shopping in a covered arcade in France. At the left-hand counter a customer is buying a pair of shoes with long pointed toes. The length was most important, for a commoner's shoes should measure half that of a burgher's, and a burgher's half that of a nobleman's. At the next counter the cloth merchant has been asked by a customer to show his stock of buttons. At the right, a dealer in silver and gold dishes, ewers and goblets is being paid.

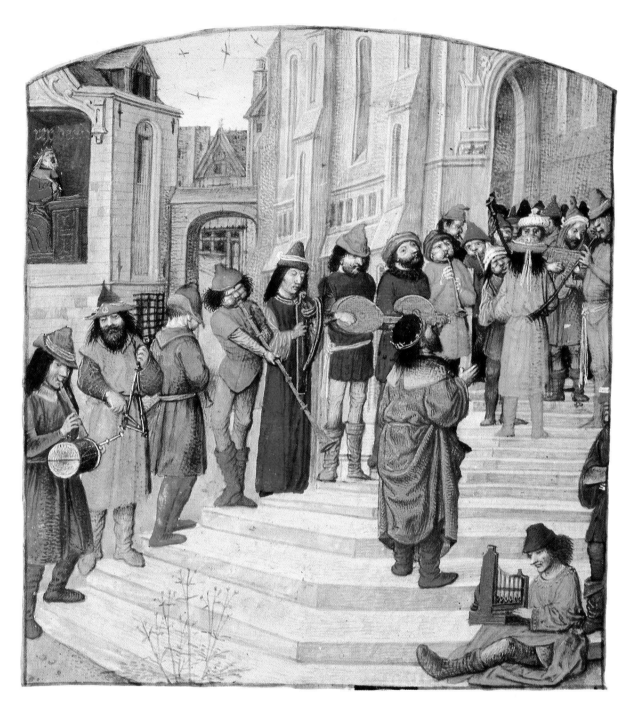

Illumination from the *Breviary of Isabella of Castile*, Flemish, *c.* 1497

Illumination from the *Hours of Mary of Burgundy*, Flemish, *c.* 1477

The arts and the church

Outdoor concert. In the Netherlands at this time, a public musical performance would lie almost exclusively in the province of the court or the larger place of worship where a fund might be laid aside for singers and musicians. In this unusual miniature, a large group of instrumentalists are conducted in a free concert on the steps of a cathedral.

Books of Hours were lavishly decorated for individual patrons, giving us vivid glimpses into their personal lives. Mary of Burgundy, daughter of Charles the Bold and granddaughter of Philip the Good, became at the death of her father the richest heiress in Europe. Here, dressed in velvet and wearing a steeple headdress, she sits with a pet dog on her lap reading a book of prayers. Through the casement window is the choir of a soaring Gothic edifice in which the scene of the Madonna and Child with angels and kneeling figures seems to symbolize the prayer Mary is reading. The figure nearest the Madonna is thought to be Mary again, painted in a different gown. Mary married Maximilian (later Emperor) of Austria in 1477, but five years later she was killed in a riding accident, leaving Burgundy under the wing of the Habsburgs.

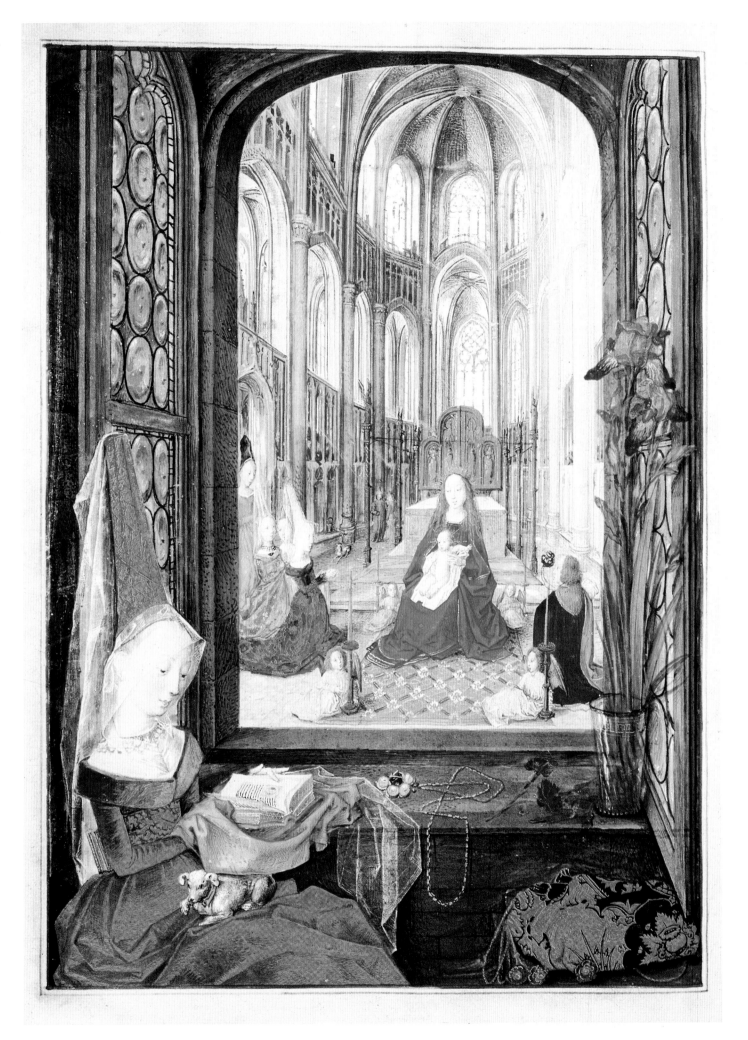

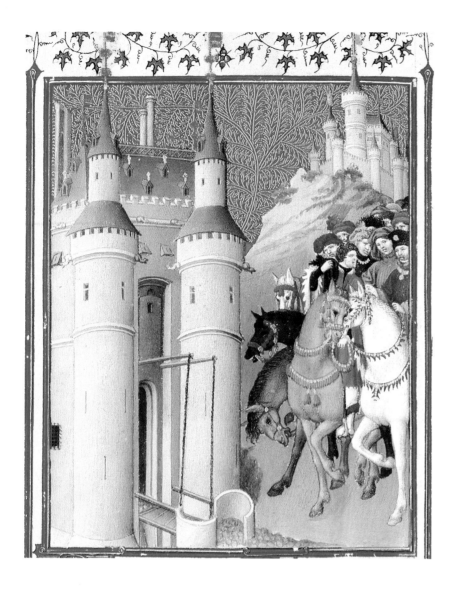

The Duc de Berry at home

Illumination from *Les Belles Heures de Jean Duc de Berry*, by the Limbourg Brothers, French, *c.* 1409–12

January, illumination from the *Très Riches Heures de Jean Duc de Berry*, by the Limbourg Brothers, French, *c.* 1413–16

Jean Duc de Berry, third son of King John II of France, received the Duchies of Berry and Auvergne *en appanage* when he was twenty, a welcome inheritance for a collector who was to become one of the greatest art patrons of all time. His particular passions included precious jewels, books, exquisitely illuminated manuscripts – and dogs, as seen here, both off and on the banquet table. He also collected châteaux, at one time enjoying the choice of luxuriating in any one of seventeen magnificent retreats, all exquisitely appointed and filled with treasures. Other extravagances – always at the expense of his disenchanted taxpayers – included a menagerie of dromedaries, ostriches, bears, chamois and other rarities. The duke entertained on the same elaborate scale. On the right, he welcomes guests to a New Year's feast at which costly gifts are distributed. The warring figures in the background belong to a tapestry on the wall behind him. In the illustration above, taken from the earlier Book of Hours by the Limbourg brothers, he rides a white horse in the grounds of another of his properties. The Duc de Berry is said to have commissioned as many as eighteen Books of Hours, six of which are known to be extant.

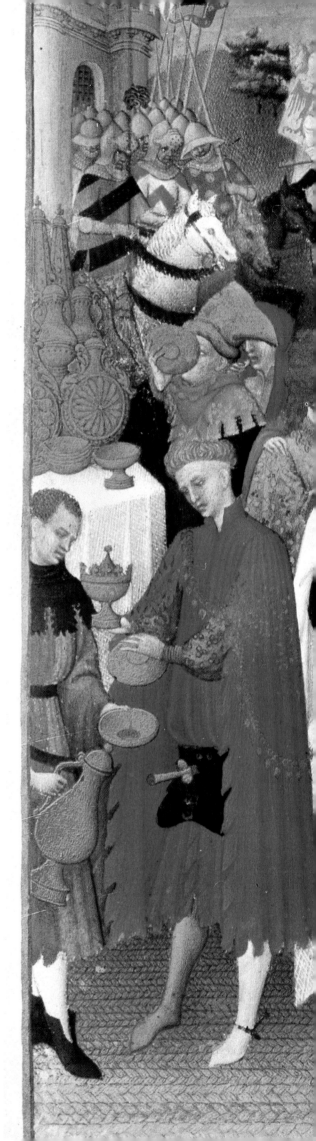

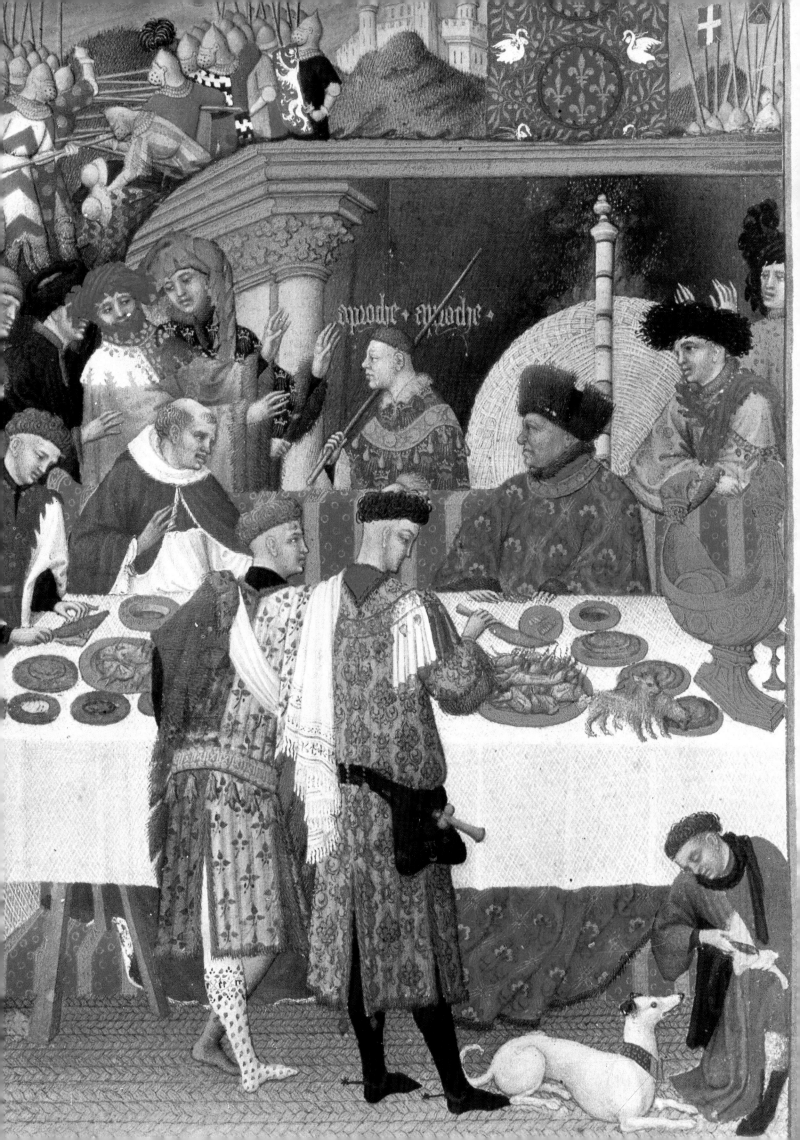

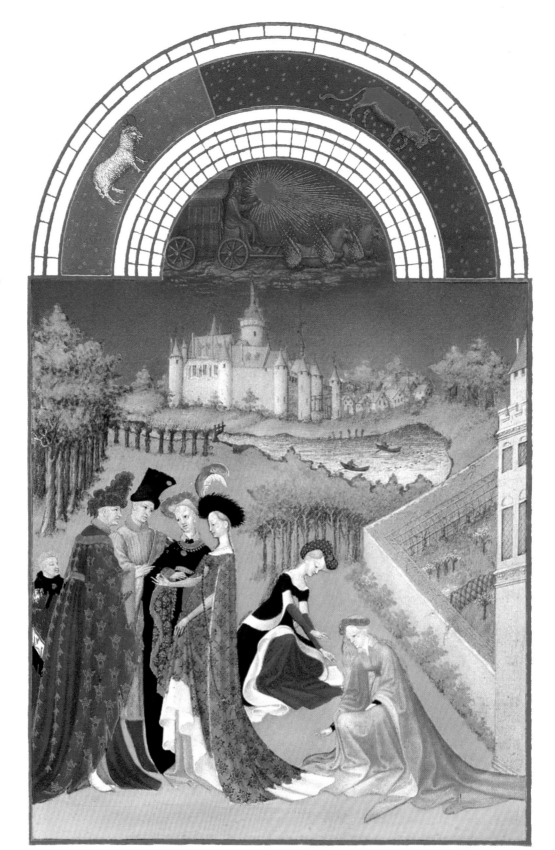

The betrothal, the subject for April in the Duc de
Berry's *Très Riches Heures*, shows the duke's huge
Château de Dourdan with the tiny village nestled
against it. In the foreground a young couple are
exchanging rings before witnesses, while two
equally decorative figures kneel to pick wild
flowers from the greenest of grass. It has been
suggested that the young man plighting his troth
might be the duke's nephew, Charles, who became
Duke of Orléans when the Burgundians murdered
his father in 1407, and who, after falling captive
to the English at Agincourt in 1415, was held
prisoner in the Tower of London for twenty-five
years (p. 35). Fruit trees bloom in the walled
garden at right, and on the distant lake two
fishermen haul in their nets. The calendar shows
the zodiac signs of Aries and Taurus, with the
chariot of the sun below them.

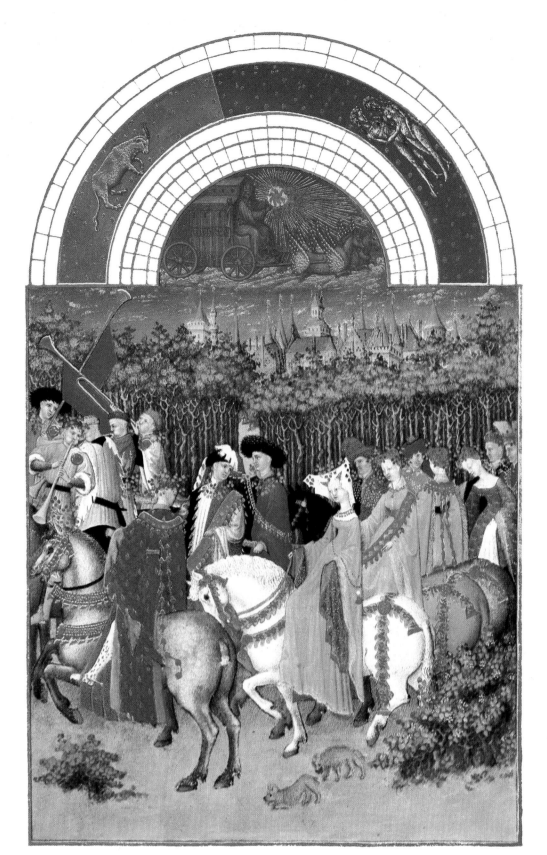

May, illumination from the
*Très Riches Heures de Jean
Duc de Berry*, by the
Limbourg Brothers, French,
c. 1413–16

May Festival. The first of May was the day the Romans gathered flowers and foliage to offer to Flora, their Goddess of Spring. A variant of this custom took hold in France where the Duc de Berry is seen with his elegant guests. Some are dressed in what was known as 'gay green', and all wear leafy crowns or garlands celebrating the day of the full flowering of Spring. Behind them, are towers, probably of the Palais de la Cîté in Paris.

The calendar shows the zodiac signs of Taurus and Gemini. The artists responsible for the masterpieces on these pages were Pol, Herman and Jean Limbourg. The three brothers left the Netherlands for France, soon to be 'discovered' by the Duc de Berry. In 1410 they became part of his well-paid entourage. Their introduction of perspective into northern European art made their exquisite work a milestone in the history of painting.

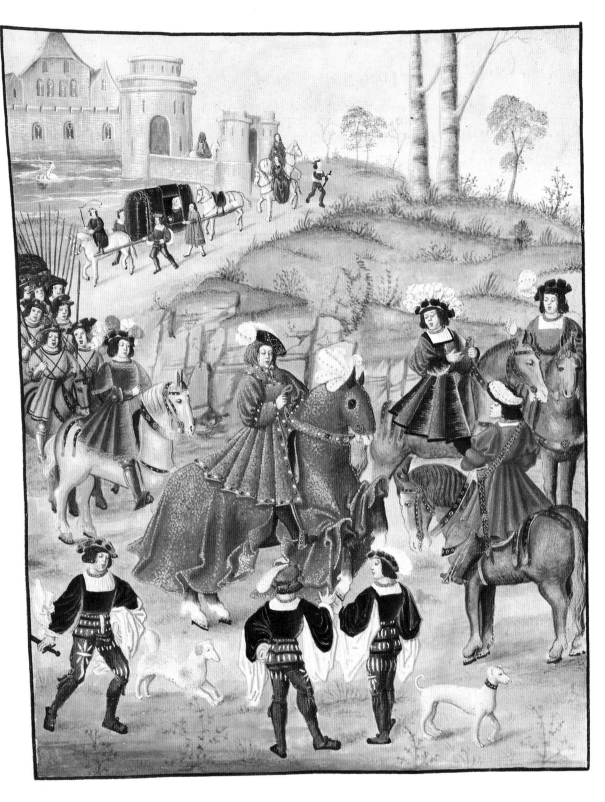

Entry of Charles V into
Bruges, Flemish, 1515

The Royal Entry

Charles V, 'greatest of the Habsburg Emperors', grandson of Emperor Maximilian and Mary of Burgundy (p. 77), was declared of age when he was fifteen, a tradition set by his father, Philip I, first Habsburg ruler of Spain. On February 18, 1515, the fifteen-year-old Charles made his Royal Entry into Bruges (*above*) as Count of Flanders and Governor of the Netherlands. Lining the route of the procession (*opposite*) are attendants in 'slashed' costumes, the new sixteenth-century fashion revealing rich under-fabrics in contrasting colours.

In honour of Charles's birthday, the merrymaker in the right foreground, seated backwards on a donkey, supports what would appear to be a huge model cake with fifteen candles (eight visible) to each layer. In 1518 Charles was formally recognized as King Charles I of Spain, ruling conjointly with his widowed and mentally deficient mother, Joanna of Castille. On his thirtieth birthday Charles was officially crowned Holy Roman Emperor by Pope Clement VII in Bologna.

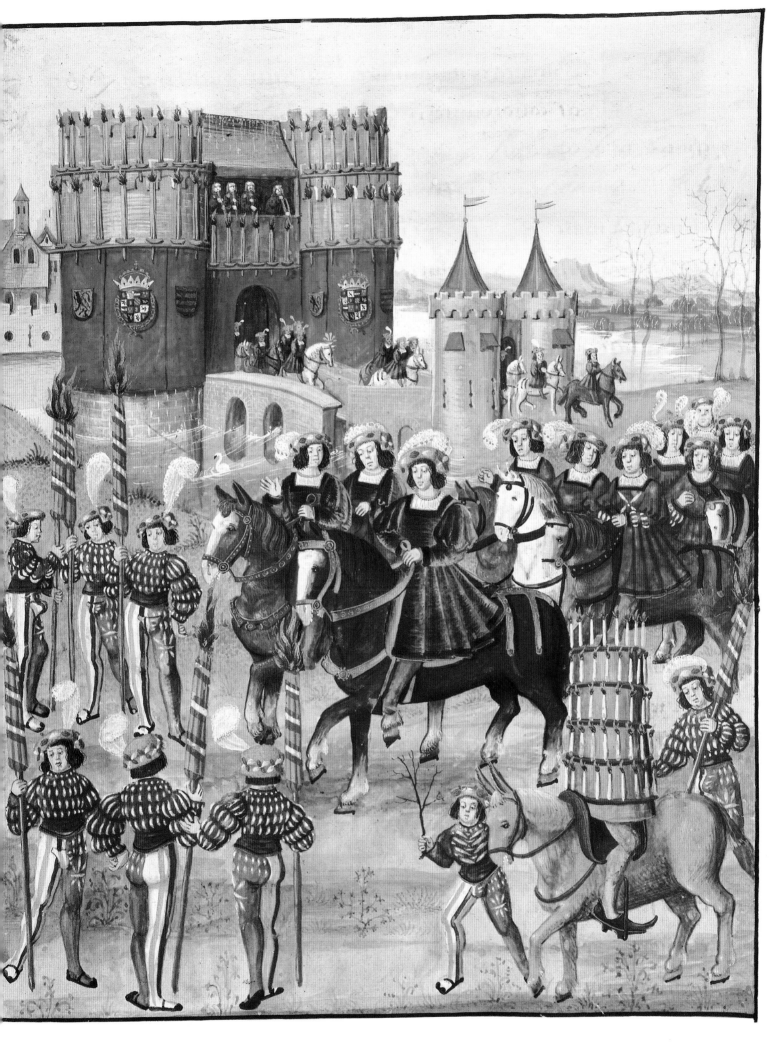

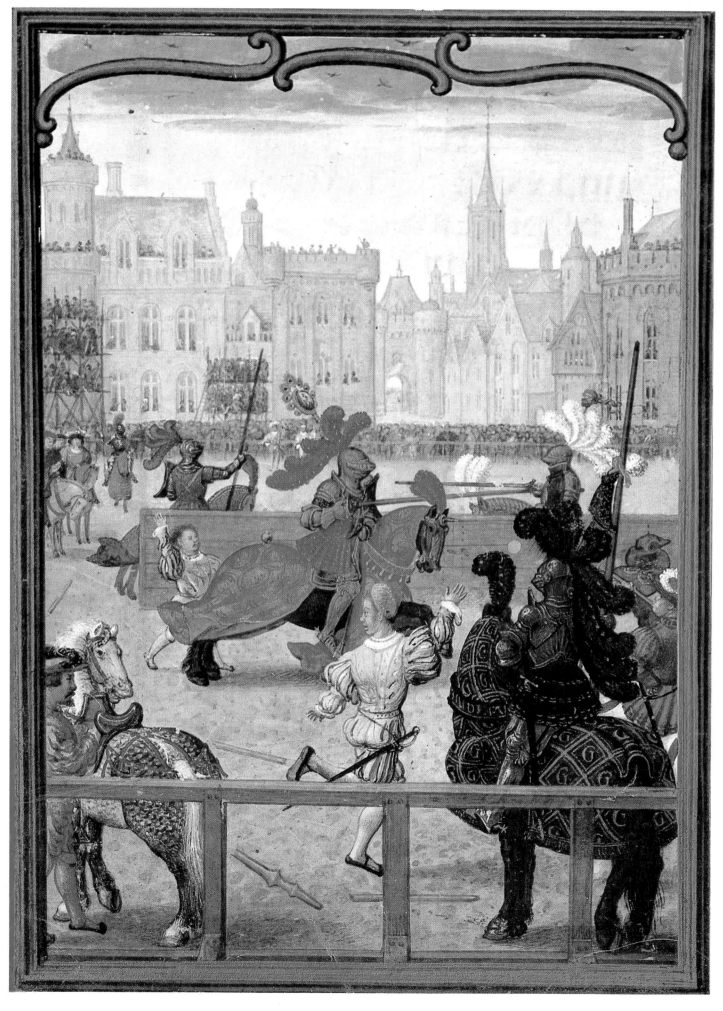

Illumination from *Les Heures de Notre Dame*, Flemish, 16th century

Passage of arms

Opposite: **Jousting** was a test of strength and a valuable training for real conflict. According to a story recounted by Froissart, the element of good sportsmanship originated in a joust that took place in May 1357. During a lull in the siege of Rennes, a young Frenchman, Bertrand du Guesclin, ventured over to the enemy camp and asked the Duke of Lancaster if any of his knights would like to try a passage of arms with him. Nicholas Dagworth came forward and a formal joust was agreed upon — three courses using spears, three strokes with axes, and three stabs with daggers. Both armies watched the contest with great pleasure, the two gallant knights 'behaving most valiantly' and parting 'without hurting each another'. As an aristocratic sport, jousting saw its last survival in the sixteenth century under the Burgundians, this example taking place in a crowded Flemish square.

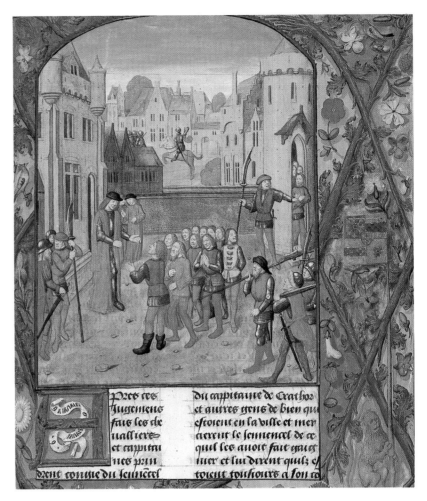

Miniature by Alexander Bening for Jean de Bueil's *Jouvencel pour Philippe de Clèves*, Ghent, 1486

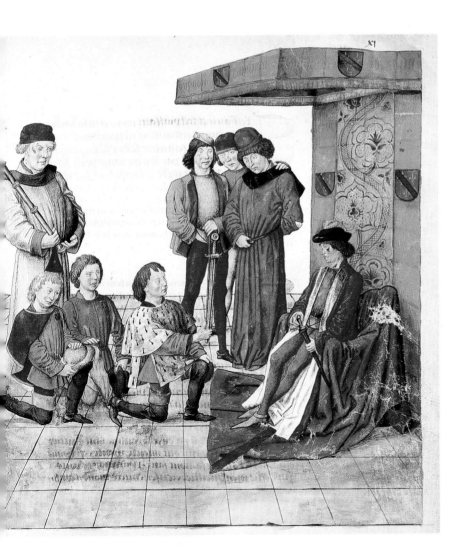

Miniature from King René of Anjou's *Livre des Tournois*, French, 1460–65

After the tournament, an act of chivalry was just as important as before and during the event. In this scene, a hundred or so years earlier than the one opposite, knights and captains surround Philip of Cleves — great-grandson of John the Fearless — to congratulate him on his prowess and wish him Godspeed.

The defendant in the tournament — here the Duc de Bourbon — is given his sword before the duel begins; one of the miniatures from René of Anjou's *Book of Tourneys* (see pages 87–96).

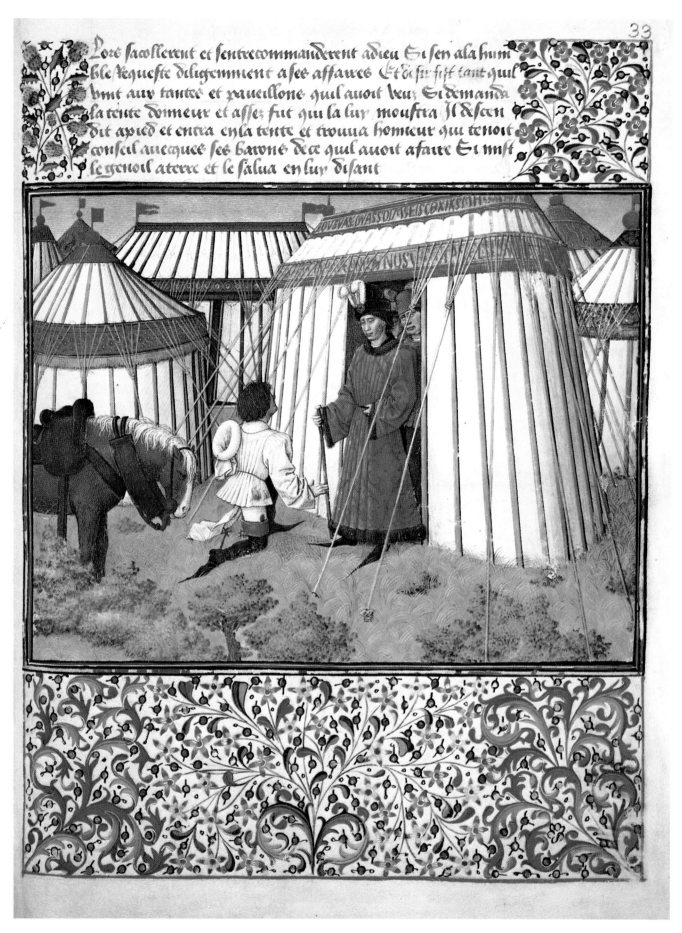

Lors saccollerent et sentrecommanderent adieu Et sen ala hum
ble requeste diligemment a ses affaires Et desir fist tant quil
vint aux tentes et pauillons quil auoit veuz Si demanda
la tente dōneur et asses fut qui la luy moustra Il desen
dit apied et entra en la tente et trouua hōneur qui tenoit
conseil auecques ses barons dece quil auoit afaire Et mist
se genoil aterre et le salua en luy disant

Miniatures from King René of Anjou's *Le Cueur d'Amours Espris*, French, 1457

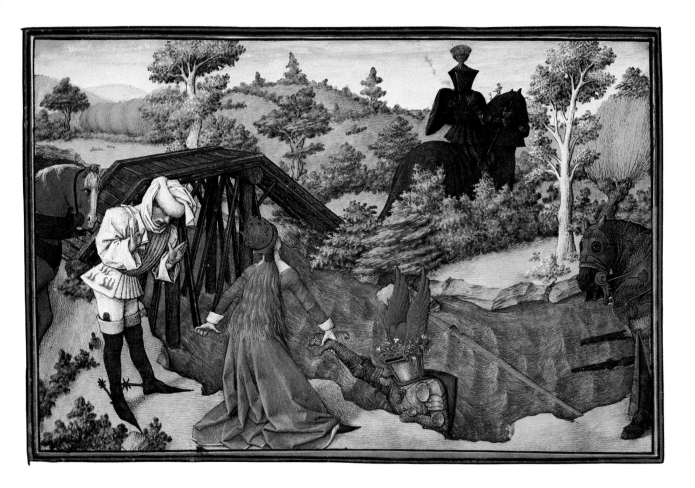

René of Anjou, artist king

King René of Anjou earned a reputation as 'the most remarkable artist king in history', his colourful life, lyrical poetry and songs, and his two extraordinary volumes, *Le Cueur d'Amours Espris* (*The Book of the Heart Possessed by Love*) and the *Livre des Tournois* (*Book of Tourneys*), each contributing to his fame.

After fighting by the side of Joan of Arc against the English when he was twenty, René became deeply involved with his own dynastic disputes and defending his long list of titles, which included Duke of Anjou and of Bar, Count of Provence and Piedmont, Count of Barcelona, Duke of Lorraine, Duke of Aragon and titular king of both Naples and Jerusalem. But by 1447 he turned increasingly to artistic and literary pursuits and to the cult of chivalry, holding court at his castles in Anjou and Provence. He founded the Order of the Crescent and, between organizing countless tournaments, in 1450 wrote and helped to illustrate the classic book on the subject from which the pictures on the pages overleaf are taken.

The Book of the Heart Possessed by Love, is a typical medieval allegory and a direct, descendant of the *Roman de la Rose*. Here René's heart is portrayed as a flesh-and-blood knight named Cueur. In the scene above, Cueur, after losing a battle with the Black Knight (Trouble) who has pushed him into the Stream of Tears, is rescued by the golden-haired Lady Hope, while his page, Desire, bows to her in homage. On the opposite page, Desire is seen kneeling before the tent of the general. Honour, whom he begs to rescue Cueur, now trapped by the Lady Sorrow and languishing in a dungeon. Honour sends Renown to the rescue, and Cueur is freed.

The tourney

pages 88–96

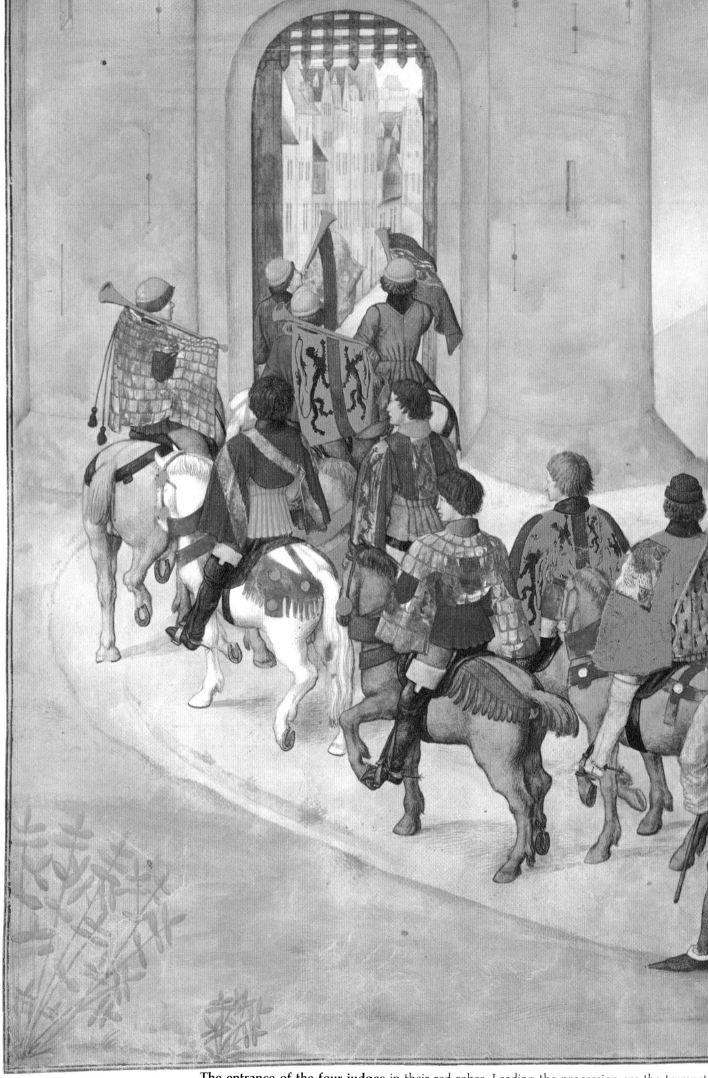

Miniatures from King René of Anjou's *Livre des Tournois*, French, 1460–65

The entrance of the four judges in their red robes. Leading the procession are the trumpete

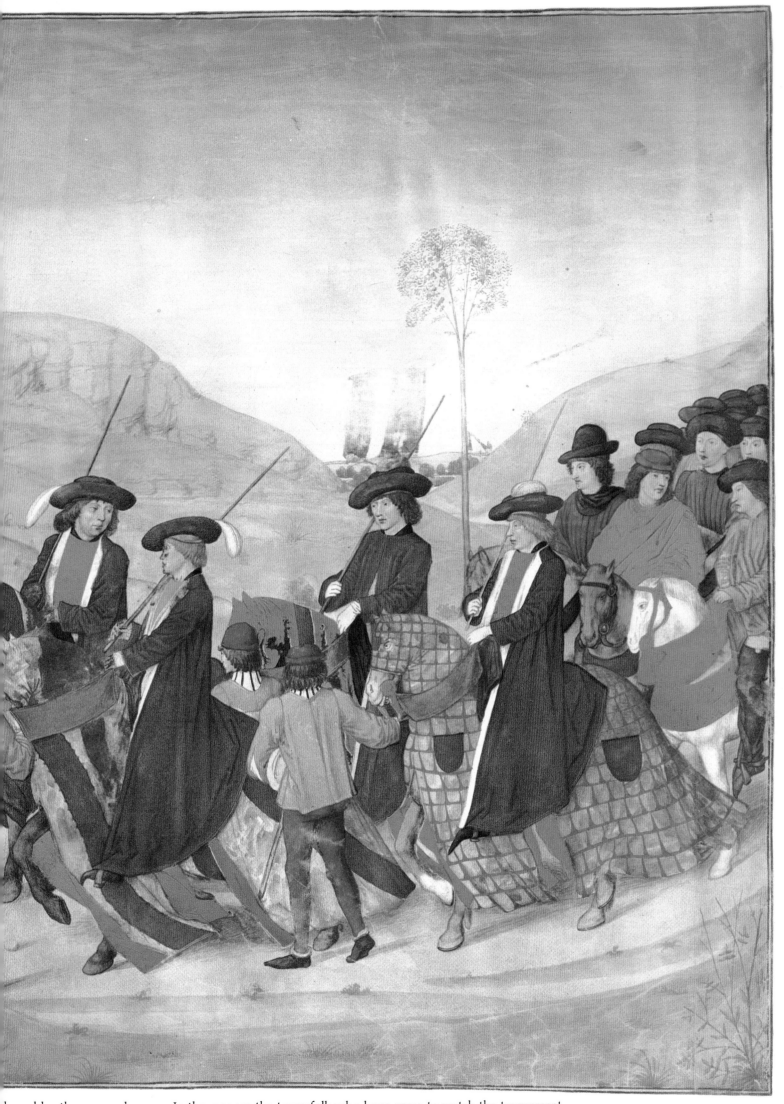

lowed by the armour-bearers. In the rear are the townsfolk who have come to watch the tournament.

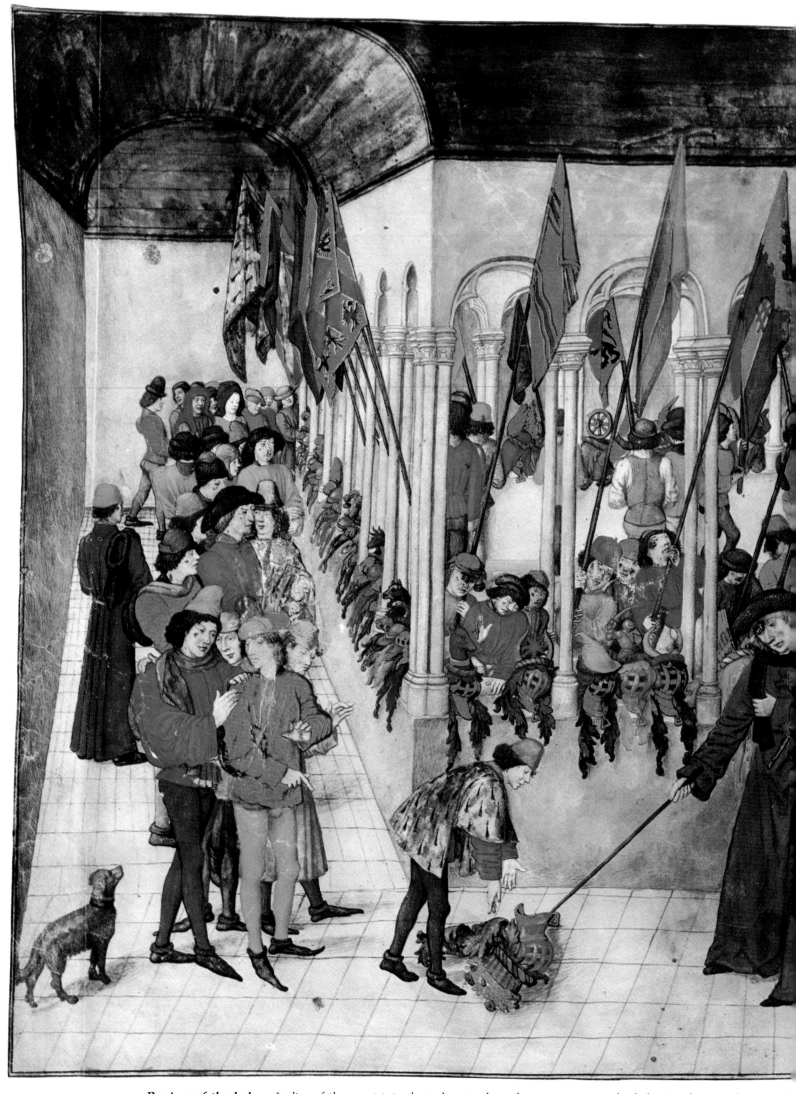

Review of the helms. Ladies of the court join the judges in their cloister to inspect the helmets of contending knigh

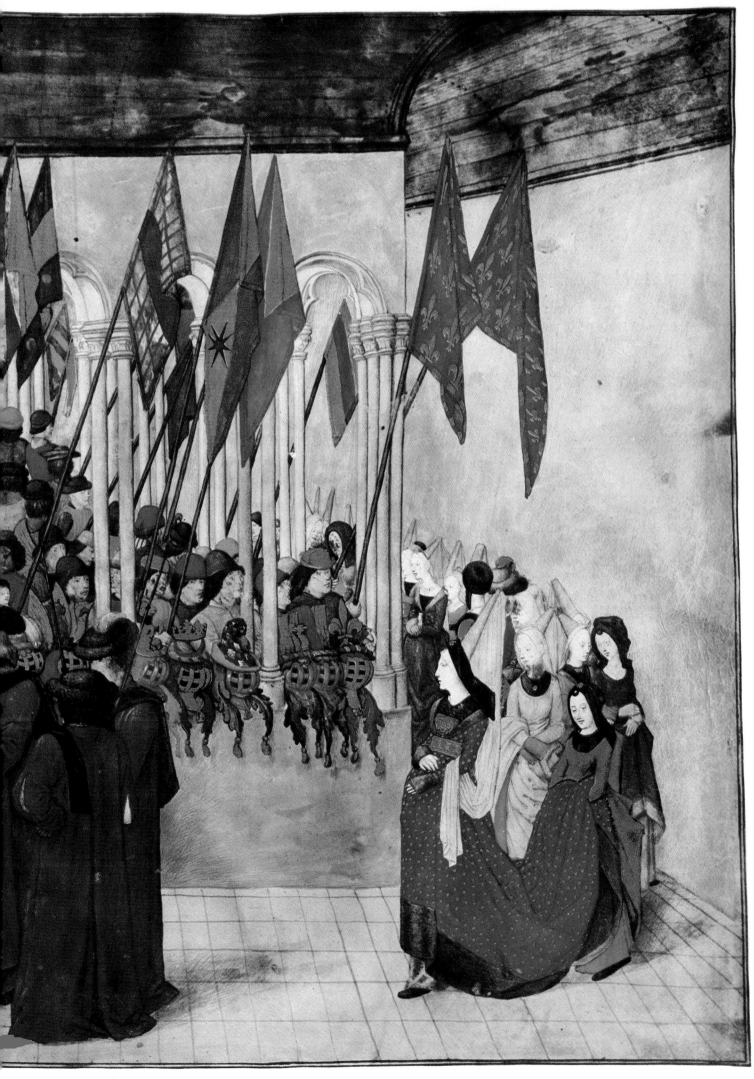

a knight had offended a lady, she would point to his helm and, if found guilty, he would then be punished.

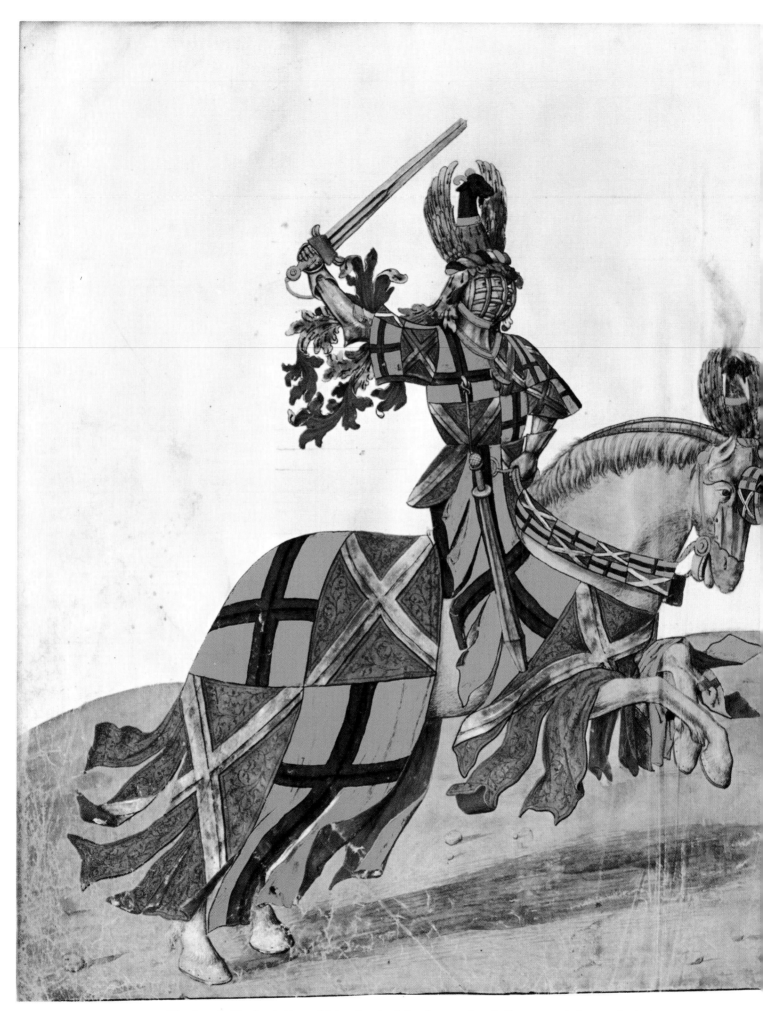

The joust. Confrontation of John, Lord of Gruthuyse, the challenger, and the Lord of Ghistelles, the defend

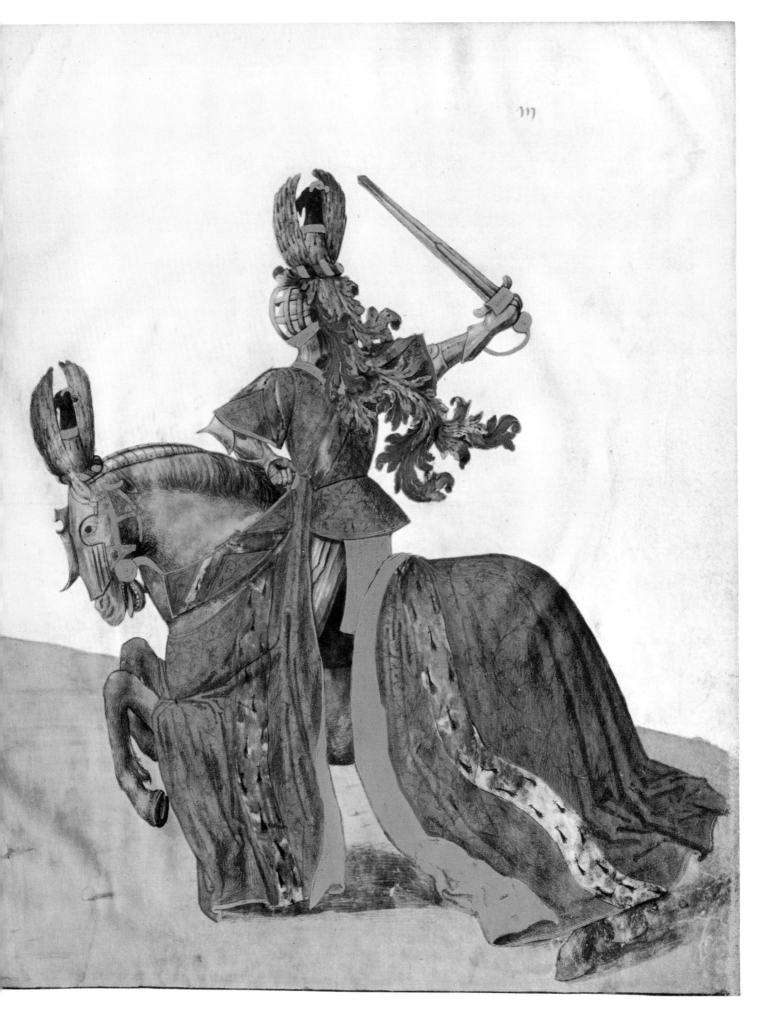

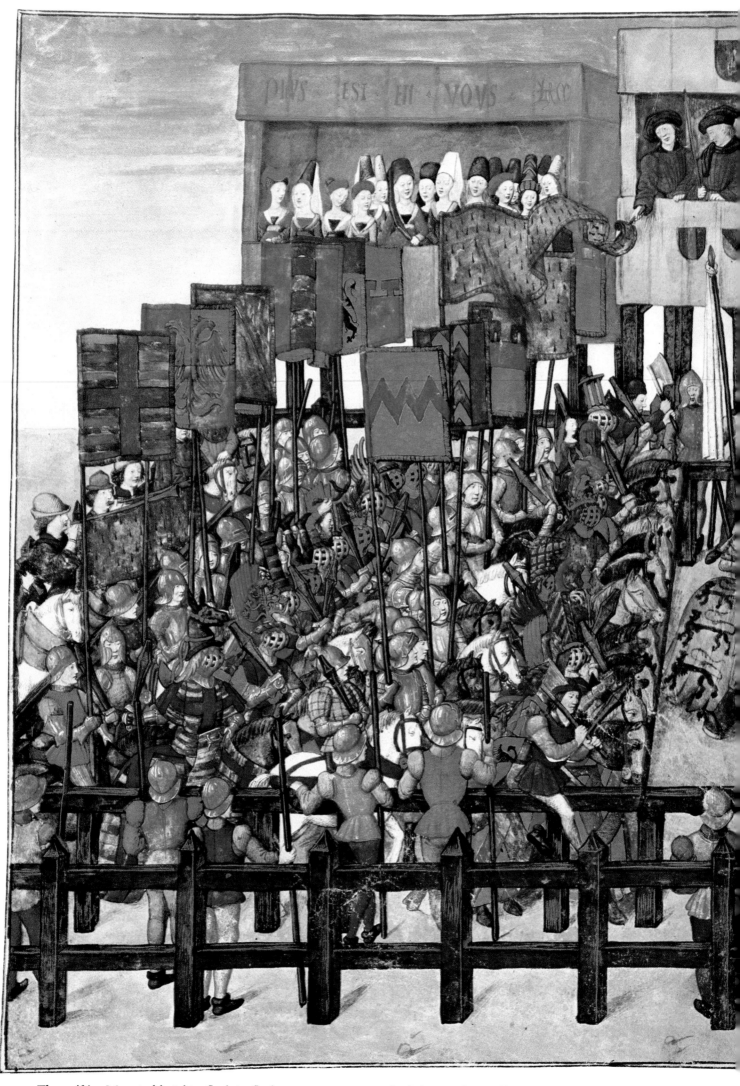

The mêlée. Mounted knights, flank to flank, set out to impress the ladies as they mill around in the lists, showing off their skil

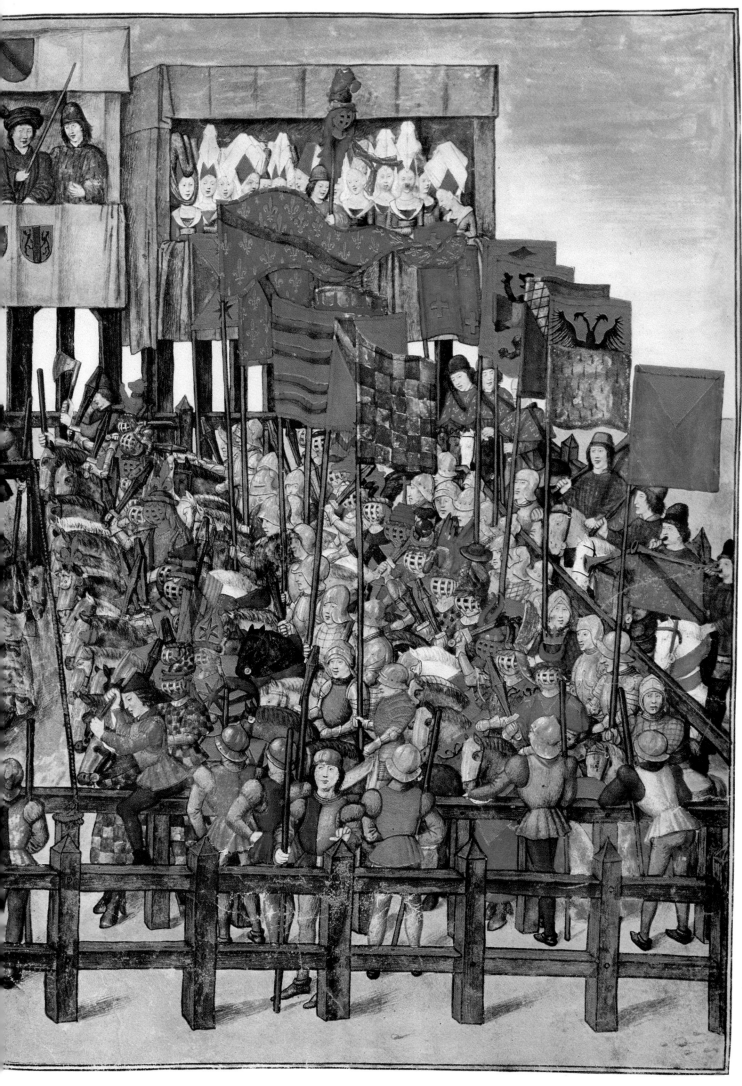

The herald will sound retreat directly the judges signal that the fighting must end.

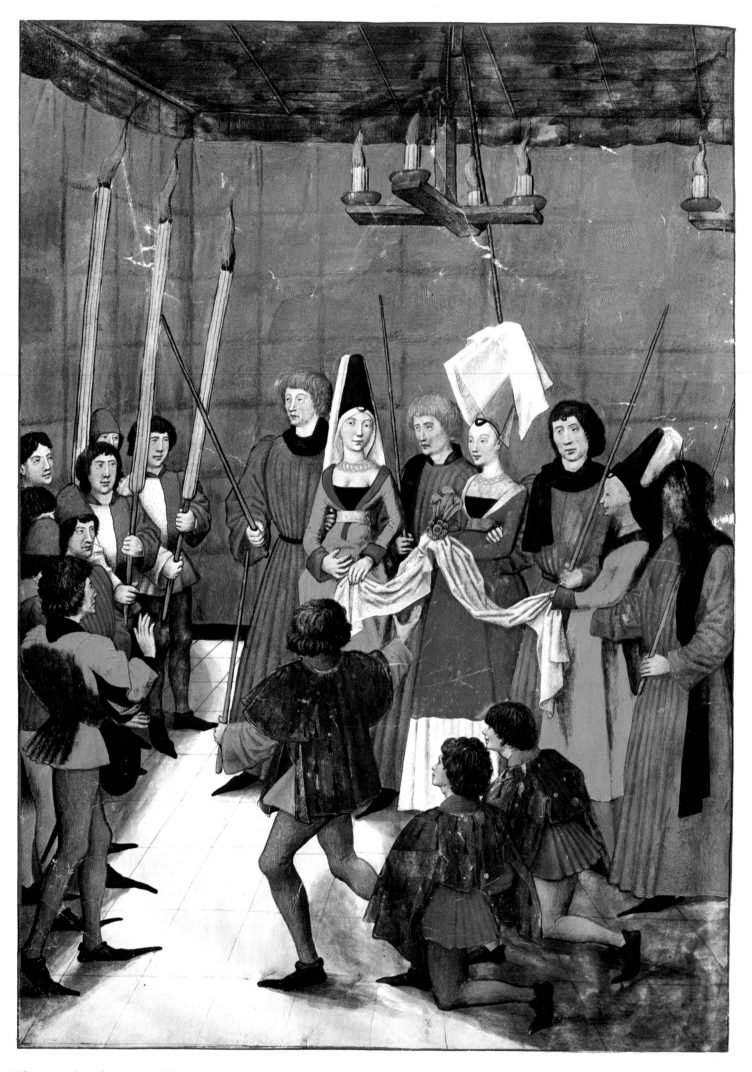

The award to the winning knight is presented by a lady of the court, following a festive dinner.

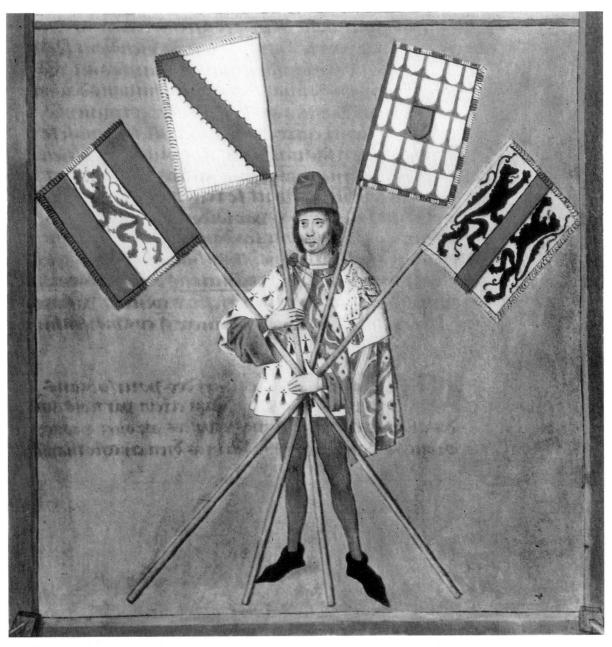

King-of-arms holding the four banners, from the *Livre des Tournois*. (Bibliothèque Nationale, Paris)

Acknowledgments . Family Trees

Sources of Illustrations

Index

Acknowledgments

The author wishes to express his heartfelt thanks to Bradford Kelleher and to other members of the staff of the Metropolitan Museum of Art, including Lisa Koch, Faye Lee and Marilyn Jensen for their encouragement, graciousness and support, and to Timothy Husband for his valuable suggestions and the contribution of his very splendid introduction. I also wish to thank all the museums involved for their wonderful co-operation in making this project possible. Last but certainly not least, my thanks to Thomas Neurath and Eva Neurath of Thames and Hudson Ltd, for whom my admiration as publishers knows no bounds. Above all, I wish to thank my dear wife, Elfrida, for the patience, help and understanding that has made my very many publishing efforts possible all these years.

A royal ball, from the *Roman de la Vidette*, c.1465 (Bibliothèque Nationale, Paris).

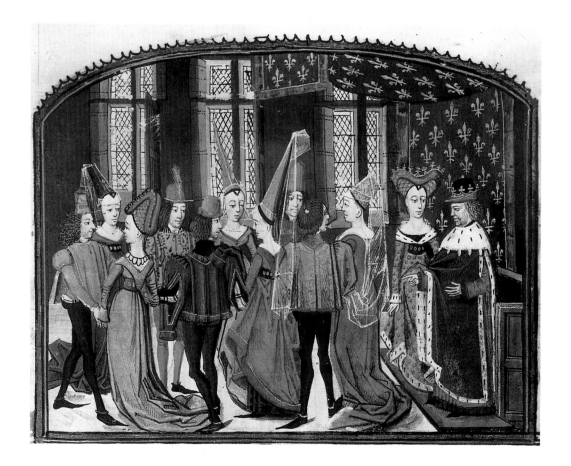

House of Plantagenet

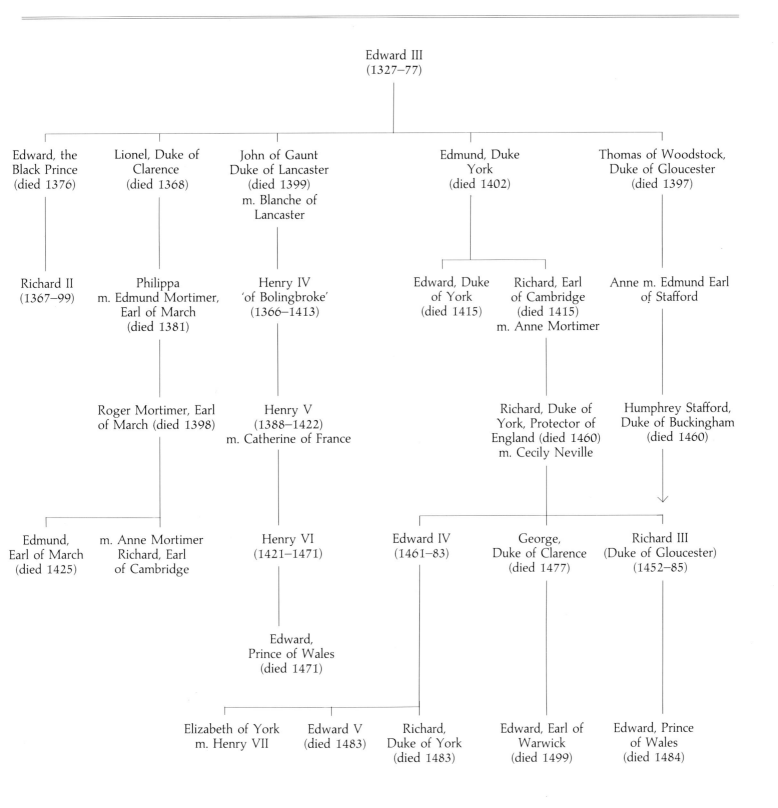

Edward III
(1327–77)

Edward, the
Black Prince
(died 1376)

Lionel, Duke of
Clarence
(died 1368)

John of Gaunt
Duke of Lancaster
(died 1399)
m. Blanche of
Lancaster

Edmund, Duke
York
(died 1402)

Thomas of Woodstock,
Duke of Gloucester
(died 1397)

Richard II
(1367–99)

Philippa
m. Edmund Mortimer,
Earl of March
(died 1381)

Henry IV
'of Bolingbroke'
(1366–1413)

Edward, Duke
of York
(died 1415)

Richard, Earl
of Cambridge
(died 1415)
m. Anne Mortimer

Anne m. Edmund Earl
of Stafford

Roger Mortimer, Earl
of March (died 1398)

Henry V
(1388–1422)
m. Catherine of France

Richard, Duke of
York, Protector of
England (died 1460)
m. Cecily Neville

Humphrey Stafford,
Duke of Buckingham
(died 1460)

Edmund,
Earl of March
(died 1425)

m. Anne Mortimer
Richard, Earl
of Cambridge

Henry VI
(1421–1471)

Edward IV
(1461–83)

George,
Duke of Clarence
(died 1477)

Richard III
(Duke of Gloucester)
(1452–85)

Edward,
Prince of Wales
(died 1471)

Elizabeth of York
m. Henry VII

Edward V
(died 1483)

Richard,
Duke of York
(died 1483)

Edward, Earl of
Warwick
(died 1499)

Edward, Prince
of Wales
(died 1484)

House of Valois

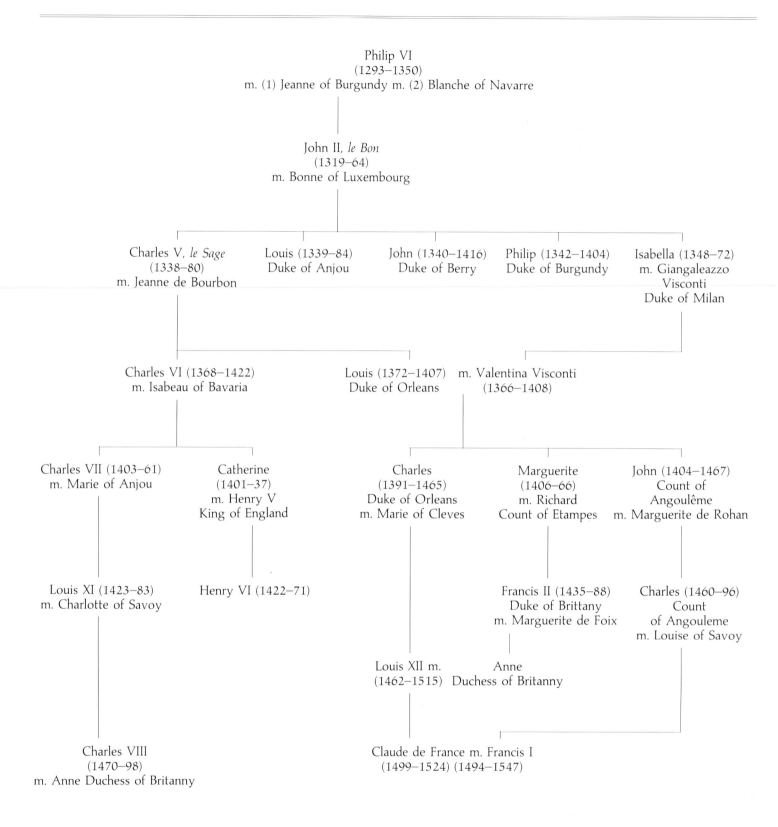

Philip VI
(1293–1350)
m. (1) Jeanne of Burgundy m. (2) Blanche of Navarre

John II, *le Bon*
(1319–64)
m. Bonne of Luxembourg

Charles V, *le Sage*
(1338–80)
m. Jeanne de Bourbon

Louis (1339–84)
Duke of Anjou

John (1340–1416)
Duke of Berry

Philip (1342–1404)
Duke of Burgundy

Isabella (1348–72)
m. Giangaleazzo
Visconti
Duke of Milan

Charles VI (1368–1422)
m. Isabeau of Bavaria

Louis (1372–1407) m. Valentina Visconti
Duke of Orleans (1366–1408)

Charles VII (1403–61)
m. Marie of Anjou

Catherine
(1401–37)
m. Henry V
King of England

Charles
(1391–1465)
Duke of Orleans
m. Marie of Cleves

Marguerite
(1406–66)
m. Richard
Count of Etampes

John (1404–1467)
Count of
Angoulême
m. Marguerite de Rohan

Louis XI (1423–83)
m. Charlotte of Savoy

Henry VI (1422–71)

Francis II (1435–88)
Duke of Brittany
m. Marguerite de Foix

Charles (1460–96)
Count
of Angouleme
m. Louise of Savoy

Louis XII m. Anne
(1462–1515) Duchess of Britanny

Charles VIII
(1470–98)
m. Anne Duchess of Britanny

Claude de France m. Francis I
(1499–1524) (1494–1547)

House of Anjou

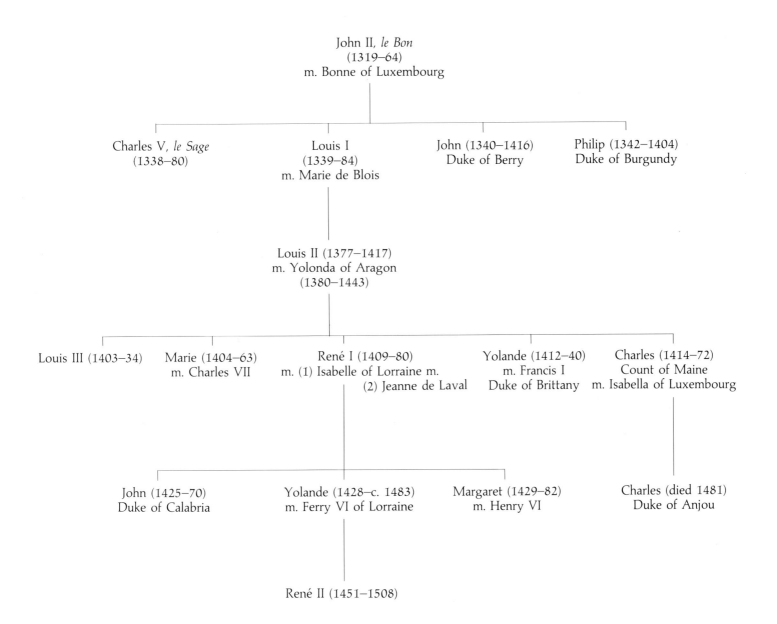

John II, *le Bon*
(1319–64)
m. Bonne of Luxembourg

Charles V, *le Sage*
(1338–80)

Louis I
(1339–84)
m. Marie de Blois

John (1340–1416)
Duke of Berry

Philip (1342–1404)
Duke of Burgundy

Louis II (1377–1417)
m. Yolonda of Aragon
(1380–1443)

Louis III (1403–34)

Marie (1404–63)
m. Charles VII

René I (1409–80)
m. (1) Isabelle of Lorraine m.
(2) Jeanne de Laval

Yolande (1412–40)
m. Francis I
Duke of Brittany

Charles (1414–72)
Count of Maine
m. Isabella of Luxembourg

John (1425–70)
Duke of Calabria

Yolande (1428–c. 1483)
m. Ferry VI of Lorraine

Margaret (1429–82)
m. Henry VI

Charles (died 1481)
Duke of Anjou

René II (1451–1508)

House of Burgundy

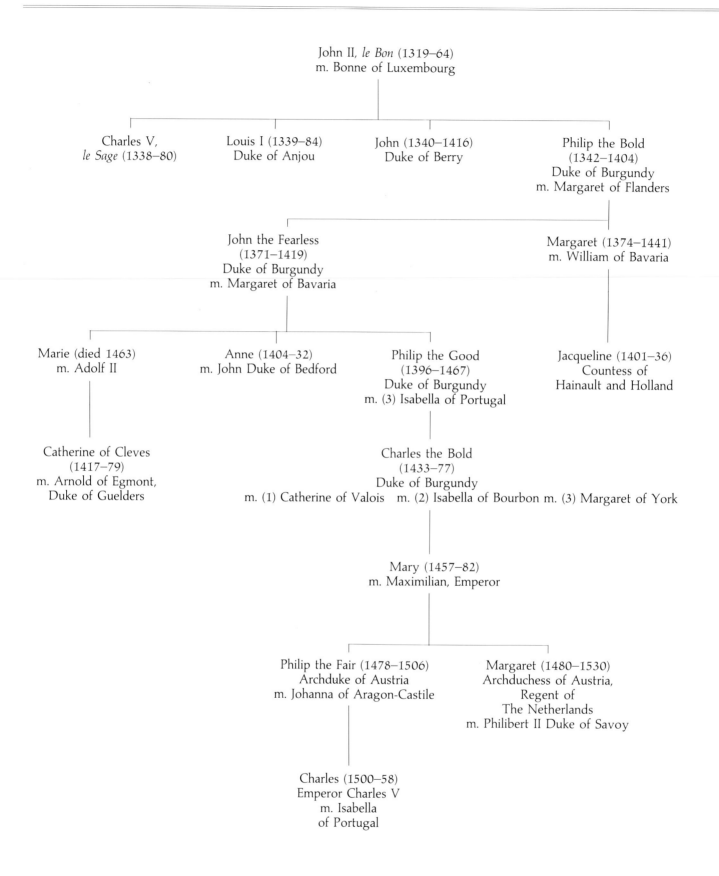

John II, *le Bon* (1319–64)
m. Bonne of Luxembourg

Charles V,
le Sage (1338–80)

Louis I (1339–84)
Duke of Anjou

John (1340–1416)
Duke of Berry

Philip the Bold
(1342–1404)
Duke of Burgundy
m. Margaret of Flanders

John the Fearless
(1371–1419)
Duke of Burgundy
m. Margaret of Bavaria

Margaret (1374–1441)
m. William of Bavaria

Marie (died 1463)
m. Adolf II

Anne (1404–32)
m. John Duke of Bedford

Philip the Good
(1396–1467)
Duke of Burgundy
m. (3) Isabella of Portugal

Jacqueline (1401–36)
Countess of
Hainault and Holland

Catherine of Cleves
(1417–79)
m. Arnold of Egmont,
Duke of Guelders

Charles the Bold
(1433–77)
Duke of Burgundy
m. (1) Catherine of Valois m. (2) Isabella of Bourbon m. (3) Margaret of York

Mary (1457–82)
m. Maximilian, Emperor

Philip the Fair (1478–1506)
Archduke of Austria
m. Johanna of Aragon-Castile

Margaret (1480–1530)
Archduchess of Austria,
Regent of
The Netherlands
m. Philibert II Duke of Savoy

Charles (1500–58)
Emperor Charles V
m. Isabella
of Portugal

Charles the Bold
watching the artist in
his workshop
(Bibliothèque Royale
Albert Ier, Brussels).

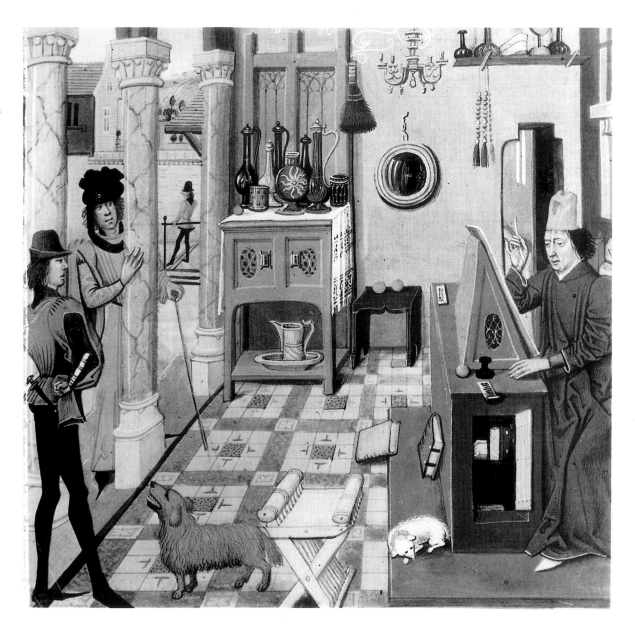

Sources of Illustrations

pp. 17, 18, 19. Heidelberg University Library.
p. 20. Stadtsbibliothek, Nuremberg. Photo Industrie Foto
 Hilbinger Gmbh.
p. 21. Bayerisches Nationalmuseum, Munich.
pp. 22–23. British Library, London.
p. 22 (left) Bibliothèque Nationale, Paris.
p. 22 (right) Great Hall, Winchester Castle. Photo Hampshire
 County Council.
p. 23. Bibliothèque Royale Albert Ier, Brussels.
p. 24. British Library, London.
p. 25. Bibliothèque Nationale, Paris.
pp. 26–34. British Library, London.
p. 35. British Library, London.
p. 36. Bibliothèque Nationale, Paris.
p. 37. Bayerische Staatsbibliothek, Munich.
p. 38. Monte die Paschi, Siena. Photo Scala.
p. 39. British Library, London.
pp. 40–41. Galleria dell'Accademia, Venice.
p. 42. Metropolitan Museum of Art, New York.
p. 43. Metropolitan Museum of Art, New York.
pp. 44–45. Galleria degli Uffizi, Florence.
p. 46. Victoria and Albert Museum, London.
p. 47. Palazzo Schifanoia, Ferrara.
p. 48. National Gallery, London.
p. 49. Metropolitan Museum of Art, New York.
pp. 50–51. Galleria dell'Accademia, Venice.
p. 52. Metropolitan Museum of Art, New York.
p. 53. Isabella Steward Gardner collection, Boston.
pp. 54–55. Palazzo Medici-Ricardi, Florence.
p. 56. Castello Sforzesco, Milan.
p. 57. National Gallery of Art, Washington.
pp. 58–59. Galleria dell'Accademia, Florence. Photo Scala.

p. 60. Bibliothèque Royale Albert Ier, Brussels.
p. 61. Musées Royaux des Beaux-Arts de Belgique, Brussels.
p. 62. Versailles Museum.
p. 63. Bibliothèque Nationale, Paris.
p. 64. Bibliothèque de l'Arsenal, Paris.
p. 65. British Library, London.
p. 66. British Museum, London.
p. 67. Bibliothèque de l'Arsenal, Paris.
p. 68. Bibliothèque de l'Arsenal, Paris.
p. 69. Bibliothèque Royale Albert Ier, Brussels.
p. 70. Österreichische Nationalbibliothek, Vienna.
p. 71. Österreichische Nationalbibliothek, Vienna.
p. 72. (top) Bibliothèque Royale Albert Ier, Brussels.
p. 72. (bottom) Musée du Louvre, Paris.
p. 73. Musée Nationale, Saint Germain-en-Laye.
p. 74. Pierpont Morgan Library, New York.
p. 75. Bibliothèque de la Ville, Rouen. Photo Giraudon.
p. 76. British Library, London.
p. 77. Österreichische Nationalbibliothek, Vienna.
p. 78. Metropolitan Museum of Art, New York.
p. 79. Musée Condé, Chantilly.
p. 80. Musée Condé, Chantilly.
p. 81. Musée Condé, Chantilly.
p. 82. Österreichische Nationalbibliothek, Vienna.
p. 83. Österreichische Nationalbibliothek, Vienna.
p. 84. Bibliothèque Royale Albert Ier, Brussels.
p. 85. (top) Staatsbibliothek, Munich.
p. 85. (bottom) Bibliothèque Nationale, Paris.
p. 86. Österreichische Nationalbibliothek, Vienna.
p. 87. Österreichische Nationalbibliothek, Vienna.
pp. 88–96. Bibliothèque Nationale, Paris.

Index

Adimiri, Boccaccio, 58, 59
Afrique, 32
Agincourt, 28, 35, 60
Alençon, Duke of, 36
Amman, Joost, 21
Anjou, Margaret of, 22, 23
Anjou, Mary of, 76
Anjou, René of, 11, 85–87
Anjou, Robert of, 39
Aphrodite (Venus), 47
Aquitaine, Eleanor of, 64
Arc, Joan of, 36
Aristotle, 46
Arthur, King, 11, 22, 64
Arthur, Prince, 8, 12

Bal des Ardents, 12, 29
Barbary Coast, 32
Barberini Panels, Master of, 52
Bellini, Gentile, 44
Benedict XIII, Pope, 29
Berry, Duchesse de, 29
Berry, Jean, Duc de, 78–81
Black Prince, Edward, The, 22, 23, 34
Boccaccio, Giovanni, 48
Bolingbroke, Henry of, 32
Borselem, Frank van, 72
Bosch, Hieronymus, 73
Botticelli, Sandro, 56
Bourbon, Duc de, 32, 85
Brabant, Duke of, 72
Bruges, 13, 82, 83
Brunswick, Otto of, 42
Burgundy, Charles, Duke of, 60, 77
Burgundy, John, Duke of, 28
Burgundy, Mary of, 77, 82

Camelot, 64
Carpaccio, Vittore, 50, 51
Castile, Joanna of, 82
Castle of Love, 23
Catherine of Aragon, 8, 82
Catherine of France, 7, 12
Charles IV, Emperor, 24, 25
Charles V, Emperor, 13, 82, 83
Charles V, King of France, 24, 29
Charles VI, King of France, 9, 12, 27, 28, 29, 36, 70
Charles VII, King of France, 36, 60
Charles VIII, King of France, 7, 8, 10
Charles the Bold, 11, 60, 76
Charles of Durazzo, 43
Clement VII, Pope, 42
Cleves, Philip of, 85
Cossa, Francesco del, 46
Court of Love, 64
Cupid, 46

Da Costa Hours, The, 74
Dagworth, Sir Nicholas, 85
Decameron, The, 48
De Gascoyne, Clarisse, 67, 68
De Guisay, Huguet, 29
De Lorris, Guillaume, 64
De Meung, Jean, 64
De Mountauban, Renaut, 67, 68
D'Este, Duke Borso, 46
Dourdon, Château de, 80
Du Guesclin, Bertrand, 85

Edward III, King, 11, 22–26, 34

Edward IV, King, 34, 60
Egyptian Soldier, 42
Eleanor of Aquitaine, 64
Elizabeth I, Queen, 82

Florence, 52, 58, 59
Foix, Count of, 63
Fouquet, Jean, 36
Francesca, Piero della, 44, 45
Froissart, Jean, 11, 26–34, 84

Gallahad, Sir, 22
Garter, Order of the, 22
Gaston III, Count of Foix, 63
Genoese. the, 32
George, Saint, 22, 23
Ghistelles, Lord of, 94
Gloucester, Earl of, 34
Gloucester, Humphrey, Duke of, 72
Golden Fleece, Order of, 60, 63
Gozzoli, Benozzo, 54, 55
Gregory, XI, Pope, 42
Griselda, the Patient, 48
Gruthuyse, Jean, Lord of, 94

Hainault, 26
Hainault, Jacoba, Countess of, 72
Henry II, King, 64
Henry IV, King, 32
Henry V, King, 7, 9, 28, 32, 60
Henry VI, King, 7, 22, 23, 34
Hundred Years' War, 26, 34

Isabeau, Queen of France, 27
Isabella, Duchess of Portugal, 63

Jacoba, of Bavaria, 72
Jerusalem, the Taking of, 24
Joan of Arc, 36
John II, King of France, 24, 26–29
John, Duke of Brabant, 72
John of Tourraine, Dauphin, 72
John the Fearless, 85
Juvenal des Ursins, Master of, 64

Lancaster, Duke of, 85
Leonardo da Vinci, 56
Liédet, Loyset, 66–68
Lille, 11
Limbourg Brothers, 78–81
Lippi, Fra Filippo, 49, 56
London, 8, 26
London Bridge, 35
London, Tower of, 35
Lords Appellant, 34
Louis VII, King of France, 64
Louis IX, King of France, 9
Louis XII, King of France, 56

Maele, Louis de, 13
Margaret of York, 11
Maximilian, Emperor, 76, 82
Medici, Cosimo, 54, 55
Medici, Piero, 54, 55
Milan, 56
Minnensänger MS., 17–19
Montefeltro, Federigo, 44

Naples, King of, 39
Naples, the Taking of, 43
Normandy, Duke of, 64
Nuremberg, 14, 20, 21

Order of the Crescent, 87
Order of the Garter, 22
Order of the Golden Fleece, 60, 63
Orléans, 36
Orléans, Charles, Duke of, 35, 80
Orléans, Duchess of, 28
Orléans, Louis, Duke of, 12, 28, 29

Palaeologus, Emperor John VI, 55
Papal Schism, 29
Parade Shield, 66
Paris, 6, 9, 10, 27, 81
Patay, 36
Peterborough Psalter, 23
Philip I, King of Spain, 82
Philip II, King of Spain, 82
Philip the Good, Duke of Burgundy, 60, 63, 76
Philippa, Queen, 26
Pleshy Castle, Essex, 34
Poitiers, 64
Prato, Knight of, 39
Prisciani, Pelegrino, 46

Rennes, Siege of, 84
Rheims, 29, 36
Ricasoli, Lisa, 58, 59
Richard II, King, 32, 34
Rolin, Nicolas, 60
Roman de la Rose, 64
Rosamond, the Fair, 64
Roses, the Wars of, 34
Round, Table, King Arthur's, 22
Roussillon, Count and Countess of, 70
Rustici, Vincenzo, 38

Samson and Delilah, 46
Sapiti, Angiola de Bernardo, 49
Savonarola, 56, 59
Schembartlauf, 14, 20
Scolari, Lorenzo, 49
Sens, Count of, 70
Sforza, Battista, 45
Sforza, Ludovico, 56
Sforza, Maximilian, 56
Siena, 38

Tourneys, Book of, 85, 88–96
Tourraine, John of, 72
Tower of London, 35
Tunisia, 33

Ucello, Paolo, 52
Urban VI, Pope, 42
Urbino, Duke and Duchess of, 44
Ursula, Saint, 50–51

Van der Weyden, Rogier, 60
Van Eyck, Jan, 60
Van Eyck, School of, 63, 72
Venice, 40
Visconti, Valentina, 28

Wanquelin, Jean, 60
Wars of the Roses, 34
Wenceslas, Emperor, 29
Wild Men, Dance of, 30, 31
William VI, Count, 72
Windsor Castle, 23

York, Duchess of, 60